Selected Works

This publication is made possible by funds from
the Fay and George Owen Sheffield Memorial Endowment
with additional support from Michael R. Thomas and the Thomas Financial Group, Ltd.

Selected Works

Outstanding painting, sculpture, and decorative art from the permanent collection

High Museum of Art, Atlanta

Curators

Donald Rosenthal
Curator of European Art

Judy L. Larson
Curator of American Art

Susan Krane
Curator of Twentieth Century Art

Donald C. Peirce
Curator of Decorative Art

Copyright 1987 High Museum of Art
All rights reserved
Published by the High Museum of Art
Atlanta, Georgia

Edited by Kelly Morris,
 assisted by Amanda Woods
Designed by Jim Zambounis, Atlanta
Type set by Katherine Gunn
 Williams Printing, Atlanta
Printed by Balding + Mansell
 International Ltd,
 Wisbech, England

Library of Congress No. 87-80790
ISBN 0-939802-43-0

Preface

A museum's permanent collection is its reason for being. The institution's programs, special events, and public stance all revolve around the presentation of the collection. Where there is a long tradition of private collecting, a museum's holdings will inevitably be the richer for it.

Such a tradition is currently being fostered in Atlanta. The High Museum's permanent collection has doubled in size – to eight thousand objects – since the 1981 publication of our previous catalogue of highlights in connection with our campaign for the new museum building. Because of greater interest in collecting, the Museum's holdings have come into sharper focus. American art, decorative art, and modern art have emerged as particular strengths.

This book about the High Museum and its treasures is offered to those who have supported the Museum in the past and those who might add to our holdings in the future. It is absolutely crucial to our future that important gifts of art come our way and that money be donated for the purchase of important art objects. It is our hope that this catalogue will demonstrate the seriousness of our purpose and will illuminate not only our assets but also our needs.

The selections for this publication were made by a committee of senior staff who took into account the quality of the objects, the need for variety in order to suggest the range of our collection, and the support received from our patrons. We could have included many other works without diluting the quality of this book, but space and economy precluded that. In order to present our collection of paintings, sculpture, and decorative arts in greater depth, we made the decision to exclude works on paper even though the catalogue would have been enhanced by the inclusion of prints and photographs. It should be mentioned that catalogues of our European art, the Crawford collection of American decorative arts, and the Richman collection of African art have been published in recent years. Catalogues of our American holdings and the Cocke collection of English ceramics are in progress.

The curators of the Museum were responsible for the texts in their particular fields, with noteworthy contributions from researcher Patricia Phagan, consultant Christine Mullen Kreamer, and assistant editor Amanda Woods. Principal credit for this book and its organization must go to our editor, Kelly Morris, and to our designer, Jim Zambounis.

It is worth noting that this catalogue came about at the direction of our Board, who recognized the need for such a publication at a time when our highest priority is the growth of the permanent collection. I note with special pleasure that this book is the first project funded from the publication endowment established by Mr. and Mrs. William Barrett Howell in memory of Mrs. Howell's parents, Mr. and Mrs. George Owen Sheffield. Without the Sheffield Endowment for Publications, we could not have produced this catalogue.

GUDMUND VIGTEL
Director

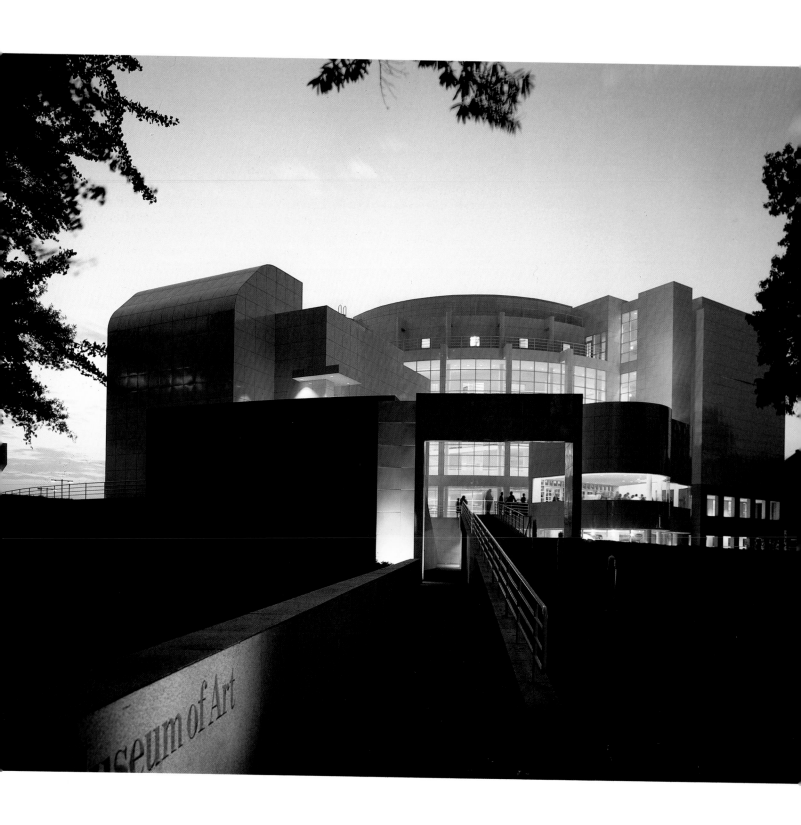

The High Museum of Art

In a remarkable burst of civic energy, the High Museum conducted the research, planning, design, construction, and fundraising for its new building in just four years. The architect was selected in June 1980, groundbreaking took place in July 1981, and the Museum's staff and collections were completely moved by August 1983. The building was completed within budget and on schedule, and was hailed as a structure of great architectural importance. The new building has elevated the High Museum from a regional institution to a national one.

The High Museum's first home was a family residence on Peachtree Street donated by Mrs. Joseph M. High in 1926. The Museum entered a period of rapid growth in 1955, when it moved into a new brick building adjacent to the old High house. In June 1962, 122 Georgia art patrons on a Museum-sponsored European tour were killed in a plane crash near Paris. The Atlanta Arts Alliance was founded in their memory, and the Memorial Arts Building, which opened in 1968, was constructed over and around the existing Museum. The Museum's usable space was not significantly increased, however, and once enclosed the Museum had no room for expansion.

The High's 1974 Long Range Planning Report concluded that the success of the Museum's future rested squarely on its ability to increase its space. The Museum could display only twenty per cent of its permanent collection, and lack of space also severely limited its ability to present important traveling exhibitions. Five years later, thanks to Atlanta philanthropist Robert W. Woodruff, the means for a new museum began to evolve. The hint early in 1979 that a major Woodruff grant might be forthcoming inspired nine months of intense planning. A feasibility study by Atlanta architects Heery & Heery found that a building of 150,000 square feet could be constructed on the land immediately north of the Memorial Arts Building at an estimated cost of $15 million.

In September an Expansion Committee was formed to set the project in motion. Task forces researched expansion projects across the country, visiting museums in twenty-three cities, and submitted their findings to the Board of Directors. The director and staff prepared a program describing the specific needs of the High Museum, taking into account standard museum practices and the findings of the task forces. Fundraising began in December with the public announcement of a $7.5 million challenge grant from Robert W. Woodruff.

In February 1980 announcements of the project were sent to architects and trade journals. By May the Building Committee had narrowed the field to six architectural firms. Each firm was interviewed in Atlanta, and in June the Board of Directors approved the selection of Richard Meier and Associates of New York. Hailed as "a supremely gifted shaper of architectural form, an inventor," Meier was the unanimous choice of the Building Committee, based on his past work, his understanding of art and art museums, his ability to adapt to physical and programmatic restrictions, and his previous

clients' enthusiasm for his integrity and professional excellence.

A similar search was held for a contractor, and in October the Museum announced the selection of Beers Construction Company as general contractor for the project. Beers Construction Company's extensive experience and demonstrated commitment to Atlanta made it a clear choice.

In the summer of 1980, the first phase of the Campaign Committee's work was launched. Solicitation of the Board of Directors brought in more than $5 million. Foundations and government sources were approached, and early in 1981, under the slogan *Help Build a Museum Big Enough for Atlanta*, the solicitation for major gifts, patron and member gifts, and public gifts began. By December 1981, a full year before the deadline, more than $9.5 million had been raised against Mr. Woodruff's challenge grant. The Campaign Committee's efforts continued in 1982, aided by a $900,000 challenge grant from the Callaway Foundation of La Grange, Georgia. Matched two-for-one by new cash contributions, this grant completed the $20 million campaign. By the time the new building was finished, eighty-five per cent of the pledges had been collected.

While the Campaign Committee was raising money for the project, the Construction Committee, working with representatives of the architect and the builder, supervised the design, construction, and budget for the building. In April 1981 architectural drawings were released to the public for the first time. In presenting the plans, Richard Meier said, "The building is designed to welcome the visitor; to arouse interest and curiosity and yet convey its sense of purpose as a contemplative place. It is a many-faceted structure, not intended to awe or overwhelm. It presents a variety of spaces, scales, and views, while maintaining a clear relationship of the architectural parts, so that the visitor really retains his orientation." The design for the new facility was completed in just over a year, and demolition and excavation of the site proceeded rapidly after the groundbreaking ceremonies in July 1981.

The new Museum is constructed of concrete slabs and steel columns and frame. The foundations were poured in December, and the skeletal structure of the building was completed in the summer of 1982. Once the structural components were in place, the building was prepared for the application of Meier's trademark porcelain-enameled steel panels. A subframe of steel girts that reflected the basic module of the panel grid was applied to the structural frame. The galleries were enclosed by the white steel panels, and the base of the building by granite panels of the same size and shape. An aluminum-framed gridded window system completed the outer skin of the building.

The Museum staff moved into the new building in June and July of 1983. The formal dedication of the new building took place on October 6. Following nine days of special events for donors and members, the new High Museum of Art was officially opened to the public on October 15, 1983.

Set well back from Peachtree Street, the building is entered

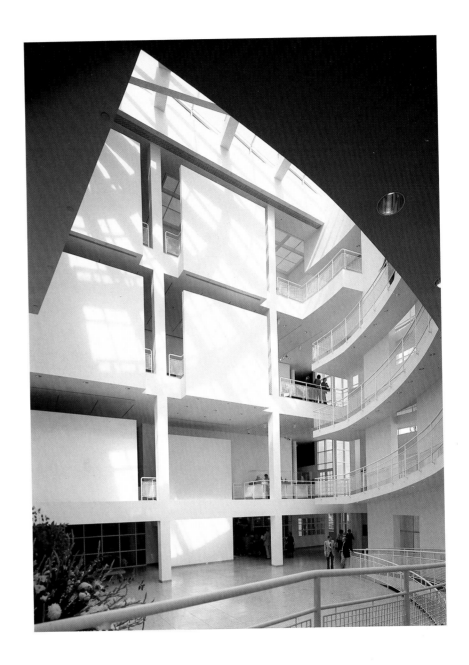

through a piano-curved reception pavilion, from which one passes into the four-story, quarter-circle glazed atrium. Light, direct and filtered, admitted through skylights, ribbon glazing, clerestory strips, or small perforations in the panel wall, is a constant preoccupation throughout and symbolizes the Museum's role as a place of aesthetic illumination. The interior ramp system and the solid atrium walls mediate between the light-filled central space and the art itself, which may be seen and reseen from various levels, angles, and distances as one moves upward. Spatial variety is created in the galleries by natural light, framed vistas, multiple scales, and glimpses into other galleries, the atrium, and the outside.

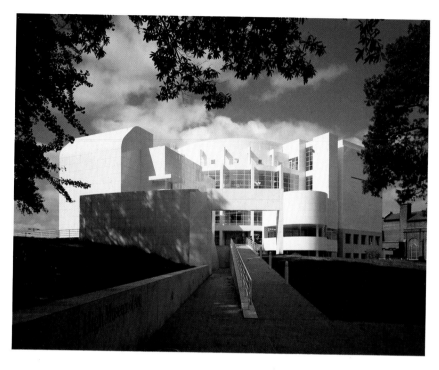

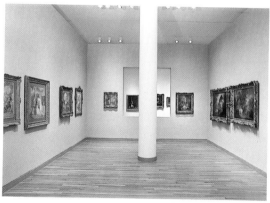

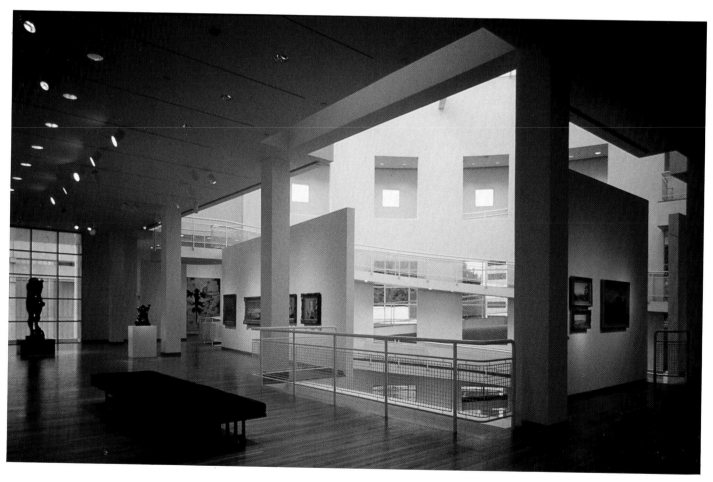

The 135,000-square-foot building includes 46,000 square feet of gallery space. The auditorium is separate from the main building at entry level. On the floor below the main level are the educational spaces—junior gallery, lecture room, workshops, and department offices.

The High Museum's new building attracted international attention and many honors. The Museum received the American Institute of Architects 1984 Honor Award, the Distinguished Architecture Award from the New York Chapter of the American Institute of Architects, the Bronze Medal Award from the Georgia AIA Chapter, the Award of Excellence from the Atlanta Urban Design Commission, the Georgia Association of Museums Award, and the Award of Excellence from the Atlanta Midtown Business Association. Richard Meier was awarded the most coveted international architecture honor of all in the 1984 Pritzker Prize.

This widespread acclaim has greatly improved the Museum's fortunes. Membership, attendance, and income have all increased dramatically. We now have the ability to show the permanent collection of more than 7,000 objects in much broader and more comprehensive displays and to place on view the most ambitious exhibitions in our history, including *The Rococo Age*; *Kandinsky: Russian and Bauhaus Years, 1915-1933*; *The Henry P. McIlhenny Collection: 19th Century French and English Masterpieces*; *China: 7000 Years of Discovery*; *Masterpieces of the Dutch Golden Age*; *The Advent of Modernism: Post-Impressionism and North American Art, 1900-1918*; *Master Drawings from Titian to Picasso: The Curtis O. Baer Collection*; *Jacob Lawrence, American Painter*; and *The Machine Age*.

Acquisitions have also increased. The permanent collection received its first major donation in 1949, when the bequest of Atlanta collector James J. Haverty brought the Museum works by Chase, Tanner, Weir, Twachtman, and Hassam. The Ralph K. Uhry Print Collection was founded in 1955. In 1958 the bequest of Edgar McBurney expanded the Museum's interests in decorative arts, and the Samuel H. Kress Foundation enriched the collection of European art with a gift of twenty-seven Italian paintings and three pieces of sculpture from the fourteenth through the eighteenth centuries.

Acquisitions of nineteenth and twentieth century American paintings have increased since the late 1960s, and American landscapes have become a major feature of the Museum's displays. The collection of American art, enhanced by the West Collection (on permanent loan), presents a rich and illuminating view of nineteenth century American culture. Collecting of contemporary American art has also accelerated, spurred by a series of major grants from the National Endowment for the Arts.

Gifts from Fred and Rita Richman beginning in 1972 have made the High Museum a regional center for the study of African art and artifacts. The Museum's African gallery opened in 1977.

The photography collection has grown steadily since its inception

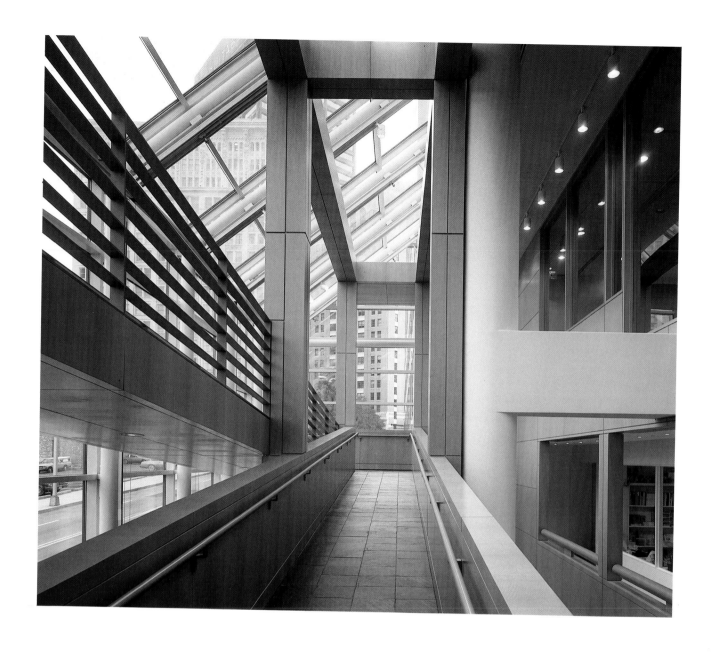

in 1974, to its present level of more than 3,000 nineteenth and twentieth century images.

Our permanent decorative arts collection has claimed national significance with the continuing expansion of the Emory and Frances Cocke Collection of English Ceramics and the 1983 unveiling of the Virginia Carroll Crawford Collection of American Decorative Arts, 1825-1917.

The High Museum's latest undertaking has been the establishment of a branch at Georgia-Pacific Center in the downtown business district. The Center's joint owners, the Georgia-Pacific Corporation and the Metropolitan Life Insurance Company, contributed the new facility, which was designed by Parker and Scogin Architects, Inc., and built by Winter Construction Company. The High Museum at Georgia-Pacific Center opened to the public in February 1986. The new branch's 4,500 square feet of gallery space are used to display traveling exhibitions and works from the Museum's permanent collection.

Selected Works

Within categories of African, European, American, Twentieth Century, and Decorative Art, objects are illustrated in loose chronological order. Dimensions are given height before width before depth.

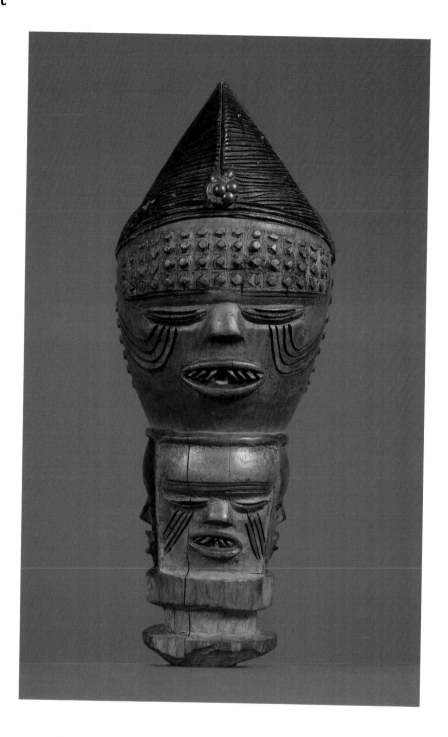

Dance Baton
Kuyu, Republic of the Congo
Wood, pigment, brass
15 inches (38.1 cm) high
Gift of Fred and Rita Richman,
1984.327

The Kuyu of the Congo and western Zaire produce elaborately carved and painted wooden dance batons called *Kebe-Kebe*. The batons may be used in initiation ceremonies which enact the Kuyu myth of origin. The carvings are fairly consistent in style. The characteristic ridged coiffure projects to a point and is accented with brass tacks. It may be surmounted by a carved totemic animal, frequently a large lizard. Most Kuyu batons have distinctive facial scarification patterns of incised lines and raised dots, found primarily on the forehead, under the eyes, and on the cheeks. The eyes are narrow and the ears are small. The open mouth reveals individually carved pointed teeth. The neck of the staff may be covered with carved human faces or geometric patterns. The baton ends in a conical handle.

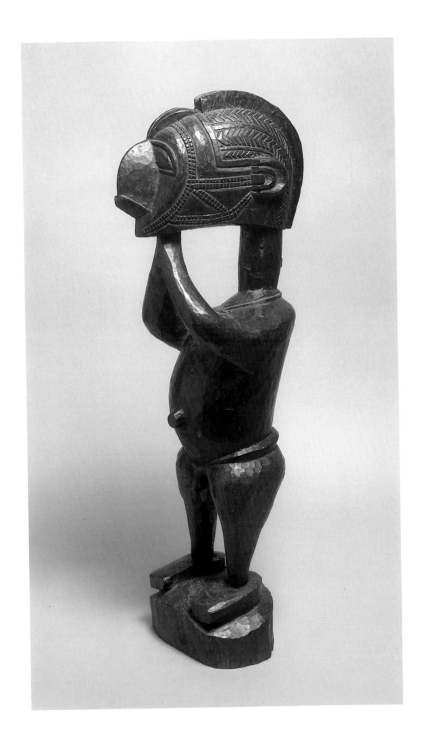

Standing Figure
Baga, Guinea
Wood
25 inches (63.5 cm) high
Gift of Helena Rubinstein, 53.12

The Baga live along the coast of Guinea, West Africa. Their social and religious life is governed by the *Simo* society, which supervises the initiation rites of young men, the funeral ceremonies of elders, and the carving of several types of masks, figures, and shrine objects. Baga art reflects both the abstraction of the Western Sudan and the naturalism of Guinea Coast style. Protective wooden figures such as this one were placed in male and female pairs in shrines located between the village and the bush to ensure agricultural and human fertility. The figure's protruding belly and prominent navel reinforce this theme of fecundity. The enlarged head with aquiline nose, elaborate coiffure, and complex facial scarification patterns is in the style of Baga *nimba* shoulder or yoke masks, worn during fertility festivals.

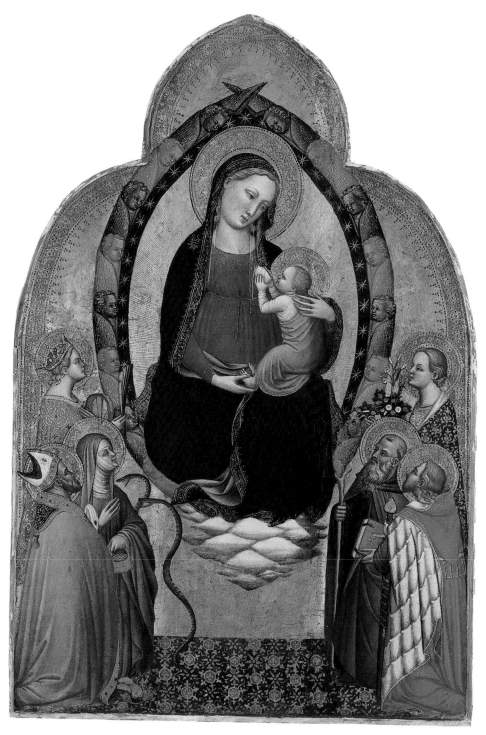

THE MASTER OF THE ST. VERDIANA PANEL
Italian, active 1390-1415

Madonna and Child with Six Saints, ca. 1390
Tempera on panel
31¾ x 21⅜ inches (80.7 x 53.8 cm)
Gift of the Samuel H. Kress Foundation, 58.49

Saints Nicholas, Catherine of Alexandria, Anthony Abbot, Julian, and Dorothy are familiar figures, but Saint Verdiana of Castelfiorentino, with her attribute of two snakes, is so rarely represented that she has furnished the pseudonym for this anonymous Florentine painter. This master, a follower of Agnolo Gaddi, depicted the Madonna of Humility a number of times as a celestial vision surrounded by a mandorla of cherubim and seraphim.

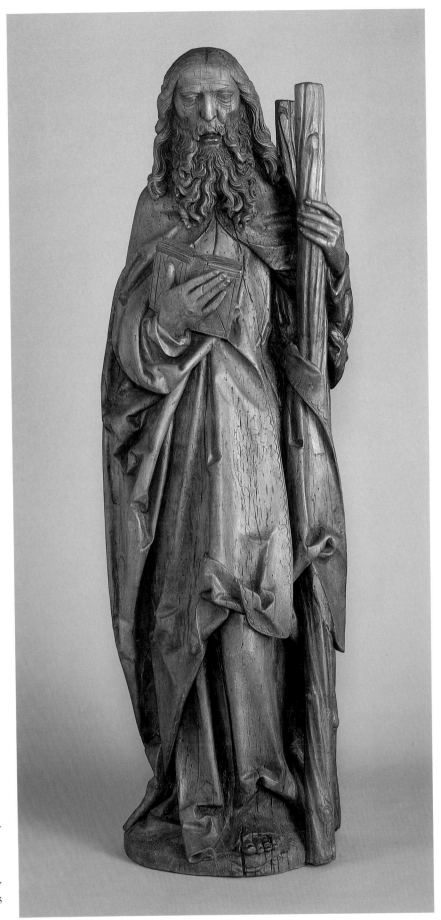

TILMANN RIEMENSCHNEIDER
German, ca. 1460-1531

St. Andrew, ca. 1505
Lindenwood, formerly
polychromed
40½ inches (102.9 cm) high
Gift of the Samuel H. Kress
Foundation, 58.57

Fully carved in the round, this lin-
denwood statue is by the greatest
sixteenth-century German sculp-
tor. Tilmann Riemenschneider
worked in the city of Würzburg,
and through his many religious
commissions in both wood and
stone attained wealth and fame,
even becoming burgomaster in
1520-21. Nevertheless, during the
Peasant War of 1525, he sided with
the peasants against the nobility
and higher clergy; when his side
lost, he was imprisoned. This
striding figure of St. Andrew, read-
ing from his Bible and carrying the
cross of his martyrdom, is remark-
able not only for the brilliance of
the carving, but also for the quality
of inner strength and steadfastness
that it radiates.

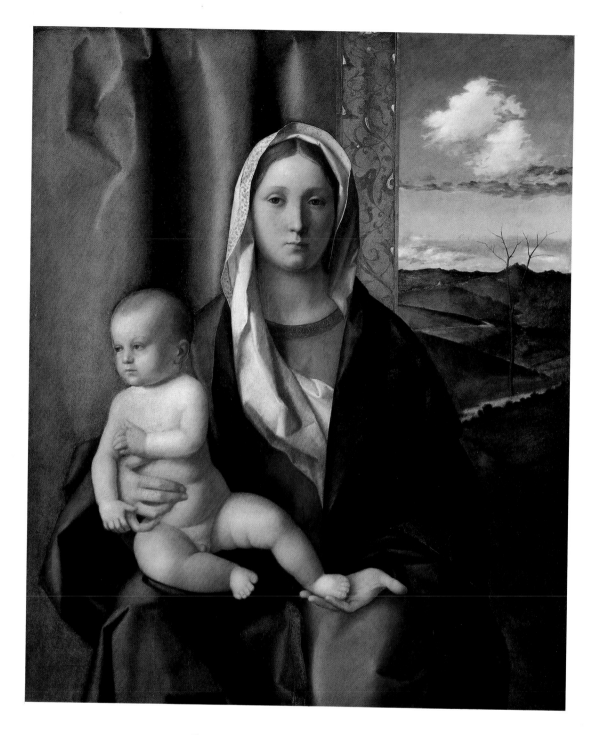

GIOVANNI BELLINI
Italian, ca. 1426-1516

Madonna and Child, ca. 1510
Oil on panel
37⅛ x 28¾ inches (94.3 x 73 cm)
Gift of the Samuel H. Kress
Foundation, 58.33

The leading painter of fifteenth-century Venice, Bellini in his mature works achieved an outstanding level of compositional balance and richness of color. In this late painting of the Madonna and Child before a landscape, an iconographic type perfected by Bellini, the symmetrically placed figure of the Virgin combines sobriety with tenderness of feeling. The beautiful landscape, with its single bare tree, may refer symbolically to the Crucifixion.

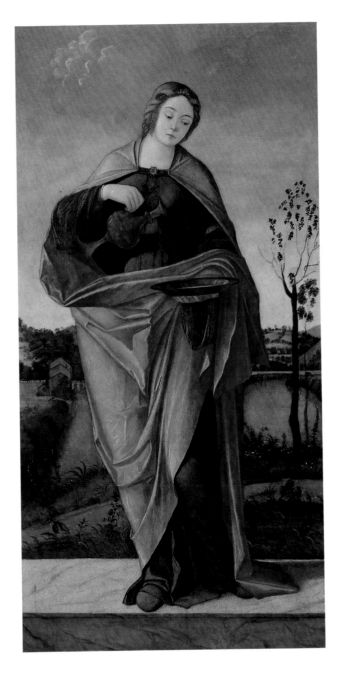 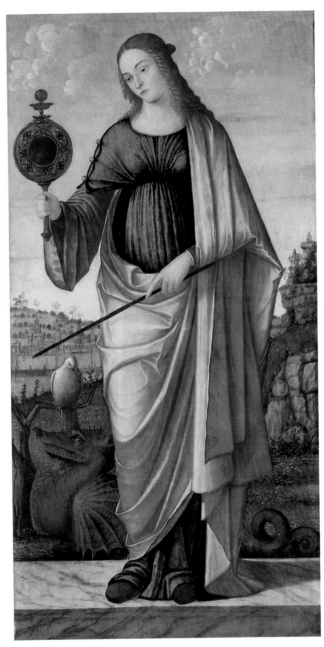

VITTORE CARPACCIO
Italian, ca. 1460-ca. 1526

Temperance, ca. 1525
Oil on wood
42⅝ x 21⅝ inches (108.3 x 55 cm)
Gift of the Samuel H. Kress
Foundation, 58.35

Prudence, ca. 1525
Oil on wood
42⅝ x 21¾ inches (108.3 x 55.1 cm)
Gift of the Samuel H. Kress
Foundation, 58.36

Vittore Carpaccio was one of the
outstanding painters of the Vene-
tian school during the Renais-
sance. His rare surviving works
reveal an exquisite sensitivity to
nature and a meticulous attention
to detail. These two elegant women
posed on a ledge before an idyllic
landscape are allegorical represen-
tations of the Virtues Temperance
and Prudence, probably from a set

of the four Cardinal Virtues. Both
in their attitudes and through their
symbolic attributes they express
an appropriate modesty and
reserve.

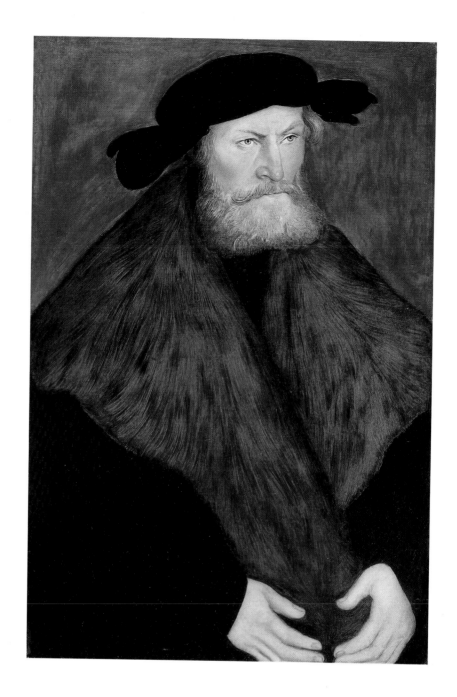

LUCAS CRANACH THE ELDER
German, 1472-1553

Portrait of Duke Henry the Devout of Saxony, 1528
Oil on panel
22½ x 15¼ inches (57.2 x 38.8 cm)
Gift of Mrs. Irma N. Straus in memory of her husband, Jesse Isidor Straus, 63.5

Cranach was called by Duke Frederick the Wise of Saxony to Wittenberg, where he worked for nearly half a century. The master oversaw a large studio and rose to be burgomaster of Wittenberg in 1537. Here he depicts one of Frederick's successors, Henry the Devout, a staunch supporter of the Protestant Reformation. The identification of the subject is based on facial similarities to the full-length portraits of the Duke that Cranach painted in 1514 and 1537. The hands may be by studio assistants, but the powerful head and bulky upper body, painted by Cranach himself, convey the Duke's determination and forceful character.

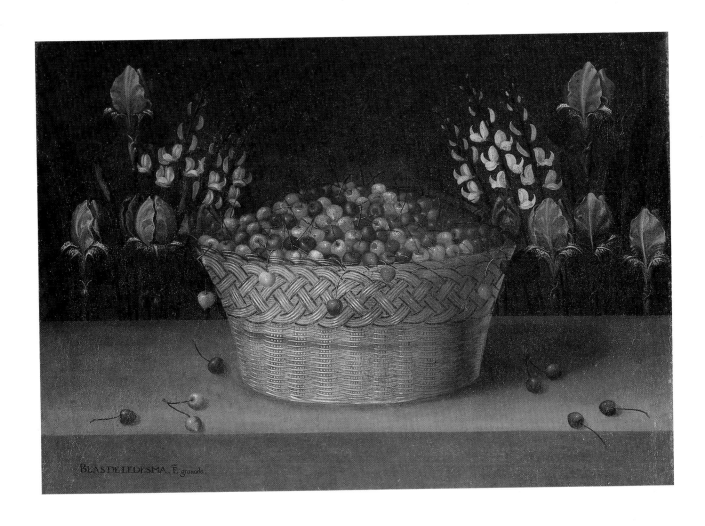

BLAS DE LEDESMA
Spanish, active late 16th-early 17th century

Still Life with Cherries, Lupin, and Iris, ca. 1610
Oil on canvas
22⅛ x 30⅞ inches (56.2 x 78.5 cm)
Great Picture Fund purchase in honor of Reginald Poland, 57.11

This still life is rare among Ledesma's works in that it bears a signature and an inscription revealing it was painted in Granada. Ledesma, who also painted architectural decorations, seems to have known the work of the older still-life painter Sánchez Cotán. The frontal, symmetrical composition, particularly in the repeated forms of the pale blue iris, gives the work a hallucinatory vividness. The depiction of the fruits on an altar-like ledge, which may have religious connotations, influenced the works of later Spanish still-life painters such as Zurbarán.

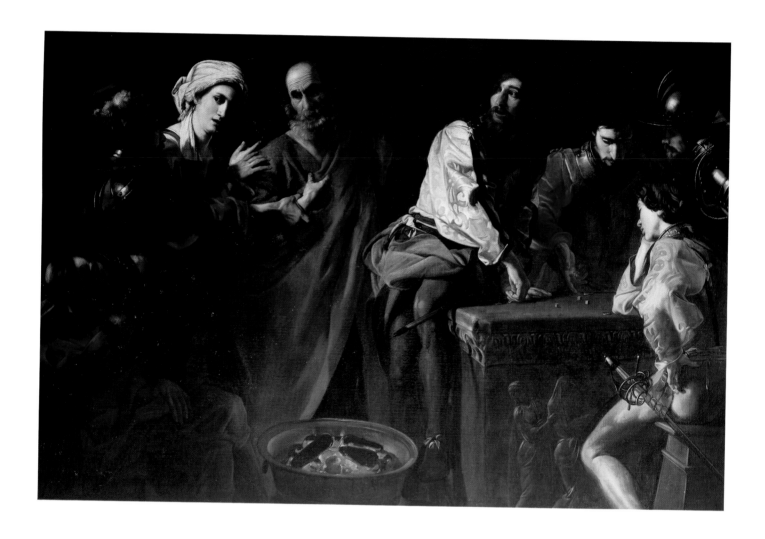

NICOLAS TOURNIER
French, 1590-1638/39

The Denial of Saint Peter,
ca. 1630
Oil on canvas
63 x 95 inches (160 x 241.3 cm)
Gift of the Members Guild in honor
of its 20th anniversary, and in
memory of Robert W. Woodruff on
the occasion of the centennial of
Coca-Cola, 1986.52

Most of Tournier's work has been
lost and his career has only been
reconstructed in recent decades.
He studied in Rome in the 1620s,
painting concert and banquet
scenes with strong chiaroscuro
effects derived from the works of
Caravaggio. Returning to France,
Tournier worked in Toulouse,
where in the 1630s he produced

powerful religious pictures of a
great emotional intensity. All
attention is on the psychological
reactions of the actors in this
drama, to whom the background
and accessories are completely
subordinated. Thrust into the spot-
light, the callous, indifferent
soldiers overshadow the threat-
ened and fearful Saint Peter.

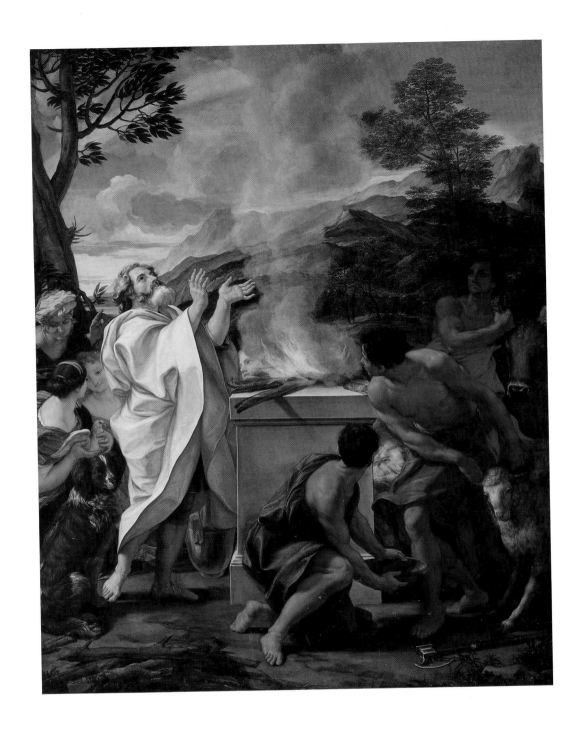

GIOVANNI BATTISTA GAULLI, CALLED IL BACICCIO
Italian, 1639-1709

The Thanksgiving of Noah,
ca. 1685-90
Oil on canvas
64½ x 51¼ inches (163.8 x 130.2 cm)
Gift of the Samuel H. Kress
Foundation, 58.30

The Genoese-born painter Il
Baciccio arrived in Rome in the
mid-1650s and soon was established
as one of the leading artists of the
city, receiving commissions from a
succession of Popes. His most
important project was the frescoed
and stuccoed illusionistic ceiling of
the Church of the Gesù, the mother
church of the Jesuit order in Rome.
This impressive painting was prob-
ably intended for an altar.

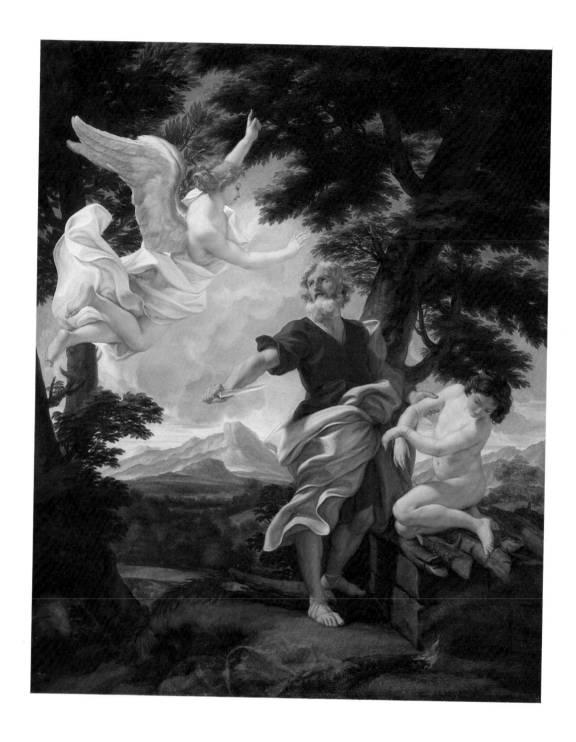

GIOVANNI BATTISTA GAULLI, CALLED IL BACICCIO
Italian, 1639-1709

Abraham's Sacrifice of Isaac,
ca. 1685-90
Oil on canvas
63¼ x 51⅝ inches (160.7 x 131.2 cm)
Gift of the Samuel H. Kress
Foundation, 58.31

This painting, like *The Thanks-giving of Noah,* depicts an Old Testament sacrifice thought to prefigure Christ's death and resurrection. The works combine a blond proto-rococo coloration with the monumental solidity of figures derived from the work of Gaulli's friend and benefactor, the great sculptor Gian Lorenzo Bernini.

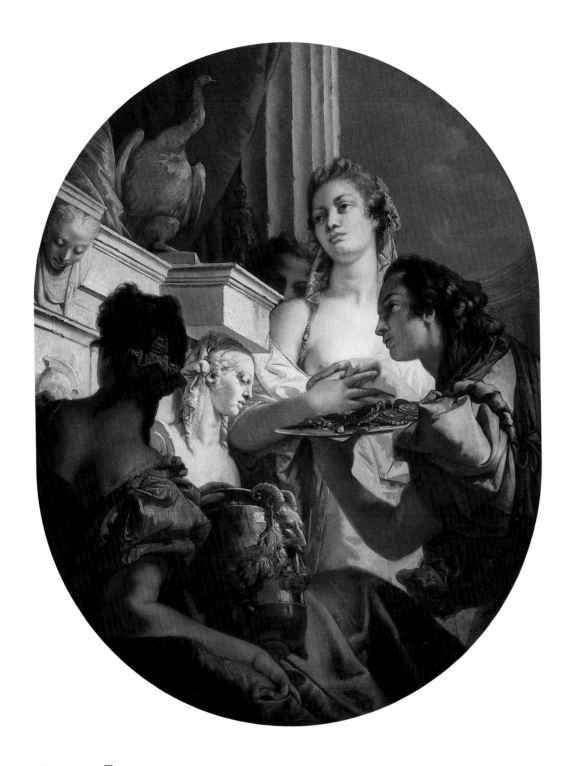

GIOVANNI BATTISTA TIEPOLO
Italian, 1696-1770

*Vestals Making Offerings to
Juno*, ca. 1745-50
Oil on canvas
56⅞ x 44⅜ inches (144.5 x 112.7 cm)
Gift of the Samuel H. Kress
Foundation, 32.6

The leading European decorative
painter of the eighteenth century,
Tiepolo was strongly influenced by
the clear, bright tonalities and
festive subjects of the Venetian
Renaissance painter Paolo
Veronese. During the 1740s Tiepolo
and his studio were busy with large
commissions throughout northern
Italy. For the Palazzo Barbaro at
San Vitale in the Veneto, Tiepolo
provided a ceiling painting depict-
ing the *Glorification of Francesco*
Barbaro, surrounded by four large
oval overdoor canvases (now dis-
persed) on antique themes relating
to marriage. In this fine canvas,
painted with classical restraint,
Roman vestals make offerings at
the base of a statue of Juno, god-
dess of marriage, here represented
by her symbol, the peacock.

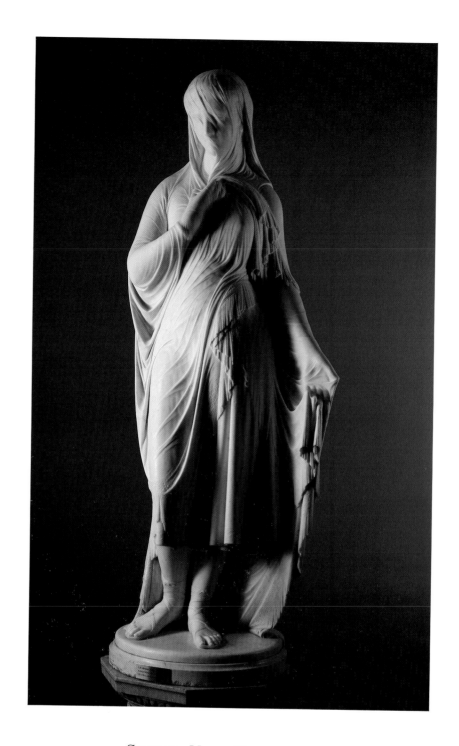

GIOVANNI MARIA BENZONI
Italian, 1809-1873

The Veiled Rebekah, 1864
White marble
64 inches (162.6 cm) high
Gift of Mrs. John B. Gordon, 27.23

In the nineteenth century, the world's leading center of sculptural production was Italy, where both foreign and native artists demonstrated a high level of technical competence. Benzoni, trained in Rome in the tradition of the Neoclassical sculptor Canova, combines idealization with naturalism in his virtuoso marble carving of a veiled figure. The subject, of which Benzoni made several versions, depicts Rebekah modestly presenting herself to her bridegroom Isaac.

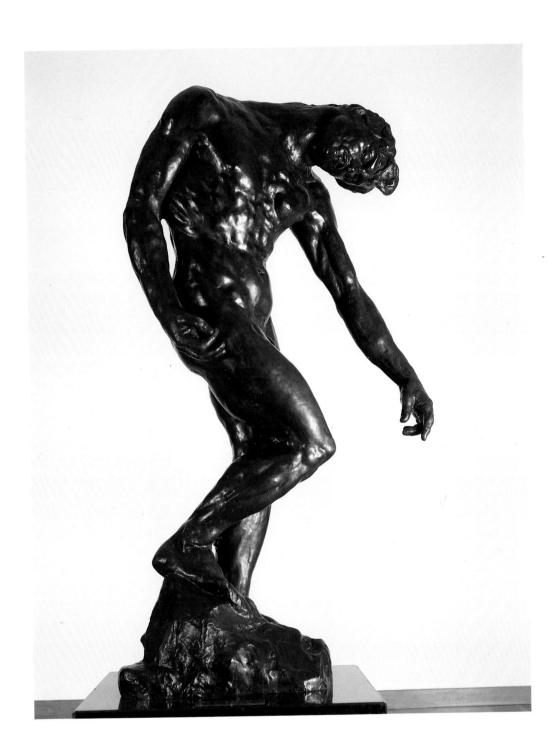

Auguste Rodin
French, 1840-1917

The Shade, 1880
Bronze, cast from original mold in 1968
75¼ inches (191.3 cm) high
Gift of the French Government to the Atlanta Arts Alliance, EL78.1983

The greatest sculptor of the nineteenth century, Rodin received a monumental commission in 1880 for a grand portal for a proposed Museum of Decorative Arts. Rodin chose to illustrate incidents and figures from Dante's *Inferno* and called the work *The Gates of Hell*. Rodin modelled over 180 figures for the huge project, but the *Gates* were not cast in bronze until 1926 (nine years after the sculptor's death). Rodin had, however, extracted single figures such as *The Thinker* and *The Shade* and made larger plasters and bronze castings of them. *The Shade* is one of the three spirits of the dead who stand on top of the *Gates*. The anguished twisting of the mighty torso and head conveys a sense of inescapable doom.

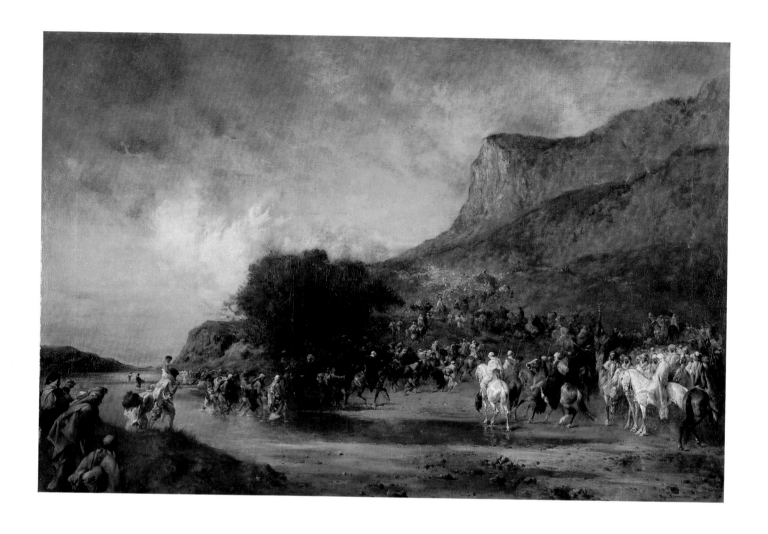

EUGÈNE FROMENTIN
French, 1820-1876

*Arabs on the Way to the
Pastures of the Tell*, 1866
Oil on canvas
25 x 41⅞ inches (63.5 x 106.4 cm)
Gift in memory of Frank D. Stout,
76.66

Eugène Fromentin, like many
French writers and artists of the
nineteenth century, was fascinated
by the Arabs of North Africa,
whom he viewed as a people in
perfect harmony with their sur-
roundings. The critic Théophile
Gautier commented, "He paints
the Bedouins so well only because
he is a Bedouin himself." Several

trips to North Africa between 1846
and 1853 supplied the painter with
the imagery for a series of Arab
genre scenes that won him recogni-
tion at the annual Paris Salons.
The High Museum's painting,
which Gautier described as one of
Fromentin's best works, was
exhibited at both the Salon of 1866
and the Exposition Universelle of
1867. George Sand wrote that the
work was "the discovery of the
Salon and a fine diamond."

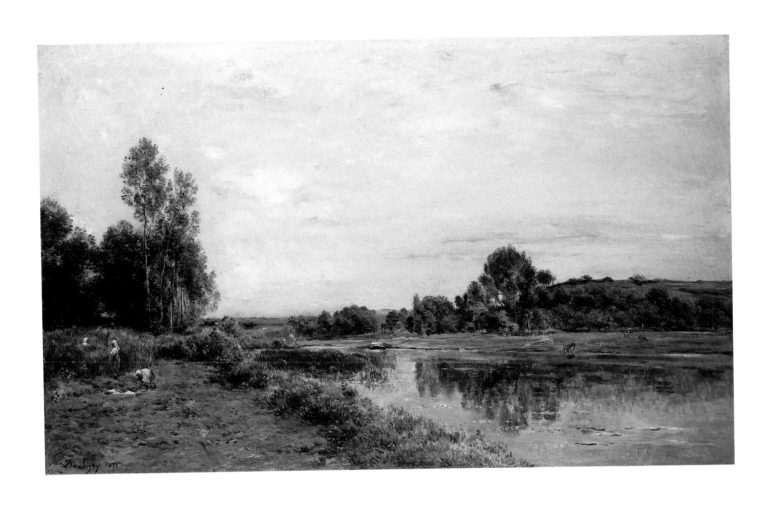

CHARLES-FRANÇOIS DAUBIGNY
French, 1817-1878

The Banks of the Oise River,
1875
Oil on canvas
24 x 39½ inches (61 x 100.4 cm)
Purchase with a bequest of Lenora
Raines and general funds in honor
of the 20th anniversary of the
Forward Arts Foundation, 1985.21

After difficult beginnings as a commercial illustrator, engraver, and landscape painter (several of his works were refused for showing at the official Paris Salon), Daubigny became one of the most famous landscape painters of France after the Revolution of 1848. Friendly with Corot and the Barbizon artists, he favored naturalistic views of the provinces of France. Specializing in scenes depicting water, Daubigny set up a studio on a boat in which he floated down the rivers in rural areas. This picture shows the mastery of light and atmosphere through which Daubigny had a great influence on Monet and the Impressionist generation. The bright tonality and freedom of brushwork in this late work may in turn indicate a reciprocal influence of the younger Impressionists upon Daubigny.

FRÉDÉRIC BAZILLE
French, 1841-1870

Beach at Sainte-Adresse, 1865
Oil on canvas
23 x 55⅛ inches (58.4 x 140 cm)
Gift of the Forward Arts Foundation in honor of Frances Floyd Cocke, 1980.62

Along with Renoir, Monet, and Sisley, Frédéric Bazille belonged to the group of young Impressionist painters who met in Paris in 1862. With Monet, who introduced him to painting out-of-doors, Bazille travelled to the Normandy coast in 1864. The following year the two painters shared a studio in Paris. There Bazille painted this large panel of the beach at Sainte-Adresse looking toward Le Havre. The work was commissioned to be hung over a door – hence the striking horizontal format. While indebted both to Monet and Manet, the painting nevertheless reveals why Bazille stood in the forefront of the new movement: with direct, bold strokes of pure color he creates a powerful composition of land, sea, and sky. Bazille produced only about seventy-five paintings in all. His brilliant career was cut short when he was killed in combat during the Franco-Prussian war in 1870.

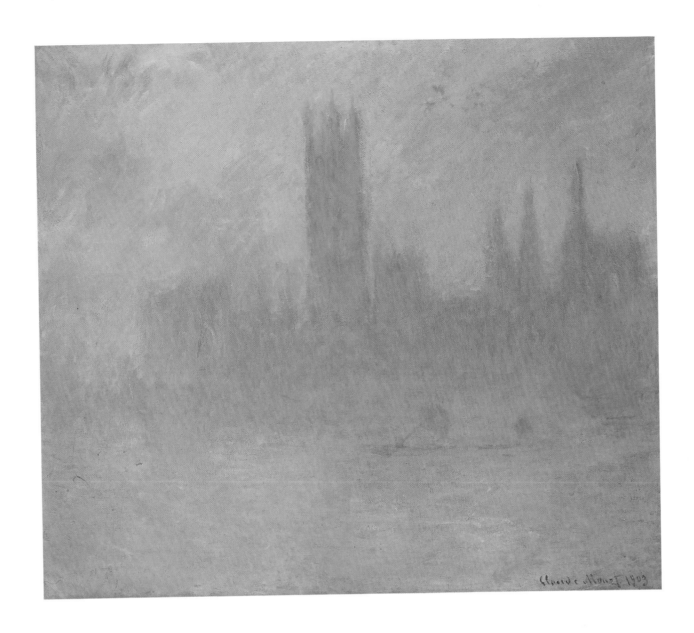

CLAUDE MONET
French, 1840-1926

Houses of Parliament in the Fog, 1903
Oil on canvas
32 x 36⅜ inches (81.3 x 92.5 cm)
Great Painting Fund purchase in honor of Sarah Belle Broadnax Hansell, 60.5

In his later years Claude Monet carried the Impressionists' attempts to render the changing effects of light and atmosphere to an extreme, producing several series of paintings of the same sites, viewed at different times of day and under different weather conditions. In the winters of 1899-1901 he worked in London. Surrounded by as many as ninety canvases, he painted his series of the Houses of Parliament on the Thames, and then took them all back to his home at Giverny to complete. Monet said, "I love London . . . and above all I love the fog." Here the mist dissolves the solid structure of the building into a floating visionary image.

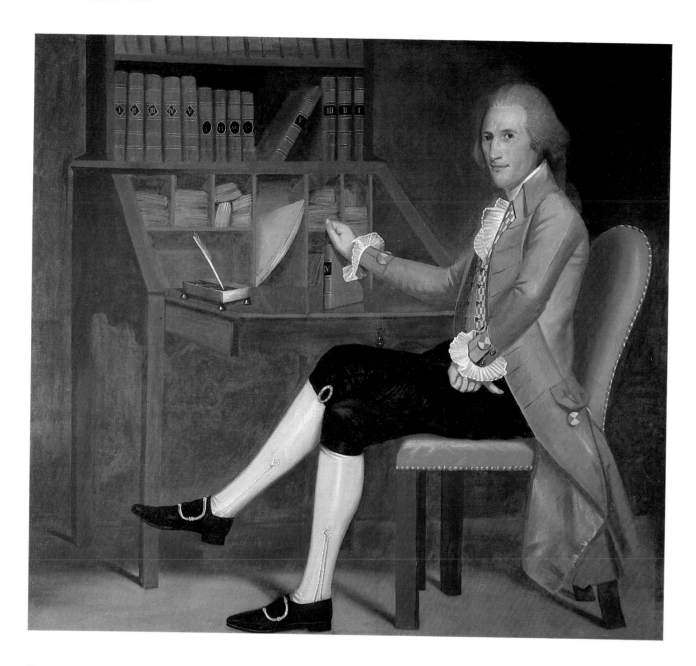

RALPH EARL
American, 1751-1801

David Baldwin, 1790
Oil on canvas
59 x 62½ inches (149.8 x 158.7 cm)
Purchase in honor of Lawrence L.
Gellerstedt, Jr., President (1984-86)
of the Board of Directors of the
High Museum of Art, with funds
given by Alfred Austell Thornton
in memory of Leila Austell
Thornton and Albert Edward
Thornton, Sr., and Sarah Miller
Venable and William Hoyt Venable,
1985.221

David Baldwin was a merchant,
director of the Bridgeport and
Newtown Turnpike Company,
founder of the Newtown Aqueduct
Company in 1803, and major
general in the Connecticut Militia.
The painter Ralph Earl went to
England during the Revolutionary
War, but returned in 1785, and was
active in New York City and then
in Connecticut, where he estab-
lished himself as a prominent
portrait painter in the Connecticut

River Valley. Full-length portrai-
ture was Earl's forte. Baldwin is
pictured here in his best dress: the
checkered waistcoat, pin-wheel
buttons, and silver buckles on his
breeches and shoes are the marks
of a successful gentleman.

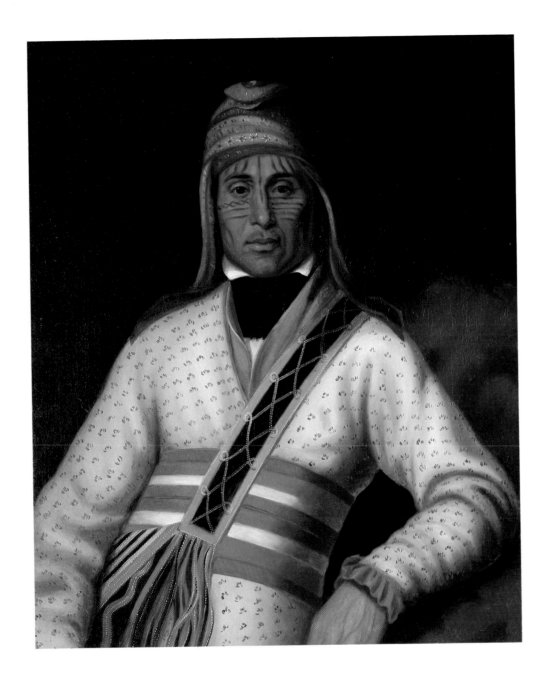

HENRY INMAN
American, 1801-1846

Yoholo-Micco, ca. 1831-33
Oil on canvas, after Charles
Bird King
30⅜ x 25½ inches (77.2 x 64.8 cm)
Anonymous gift, 1984.176

This is a copy of a painting by
Charles Bird King, who was com-
missioned to paint portraits of
Indian leaders when they visited
Washington. Thomas McKenney,
chief administrator of Indian
affairs from 1816 to 1830, published
a series of lithographs based on
King's portraits. For this project,
McKenney borrowed the King por-
traits so that graphic artists could
copy them onto lithographic
stones. In fear of having the loan
revoked, McKenney commissioned
Henry Inman to copy the por-
traits. When most of King's
originals were lost in a fire at the
Smithsonian in 1865, the Inman
portraits became the single most
important documentation of the
Indians of the early Federal
republic.

"Yoholo" means one of royal
blood and "Micco" means leader or
chief. This proud, handsome Creek
chief was known as an articulate
and learned speaker. He urged his
tribesmen to move peacefully to
the lands that had been set aside
for them.

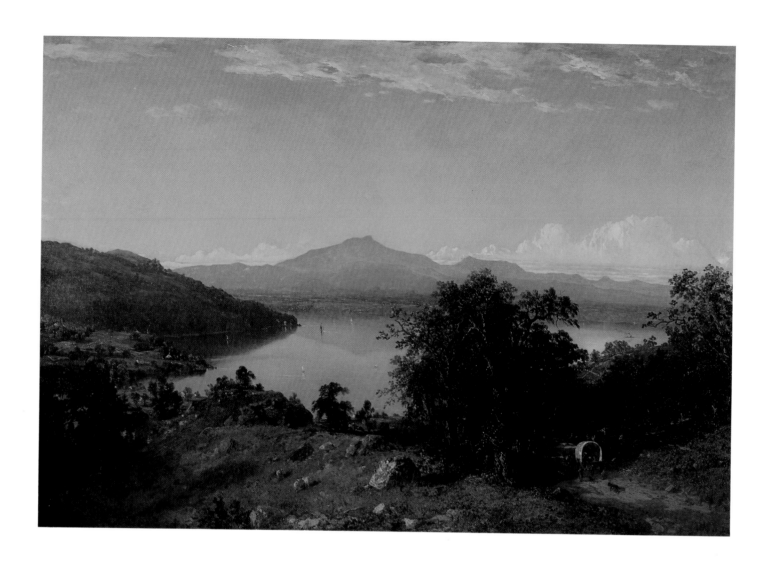

JOHN FREDERICK KENSETT
American, 1818-1872

*Camel's Hump from the
Western Shore of Lake
Champlain*, 1852
Oil on canvas
31 x 45 inches (78.8 x 114.3 cm)
Gift of Virginia Carroll Crawford,
76.67

Kensett was among the most
prominent artists of the second
generation of the Hudson River
School in the 1850s and 1860s. After
early training as an engraver, he
spent seven years in Europe study-
ing painting. Returning to New

York in 1847, Kensett devoted the
remainder of his life to landscape
painting, concentrating on the New
England countryside. This view of
Camel's Hump depicts the highest
point in the Green Mountains of
Vermont. Kensett fills the fore-
ground with detail, recalling his
training as an engraver. The eye is
led beyond the lakeshore to the
distant mountains silhouetted
between sky and water. The glow-
ing light that suffuses this painting
heralds Kensett's Luminist works
of the 1860s and 1870s.

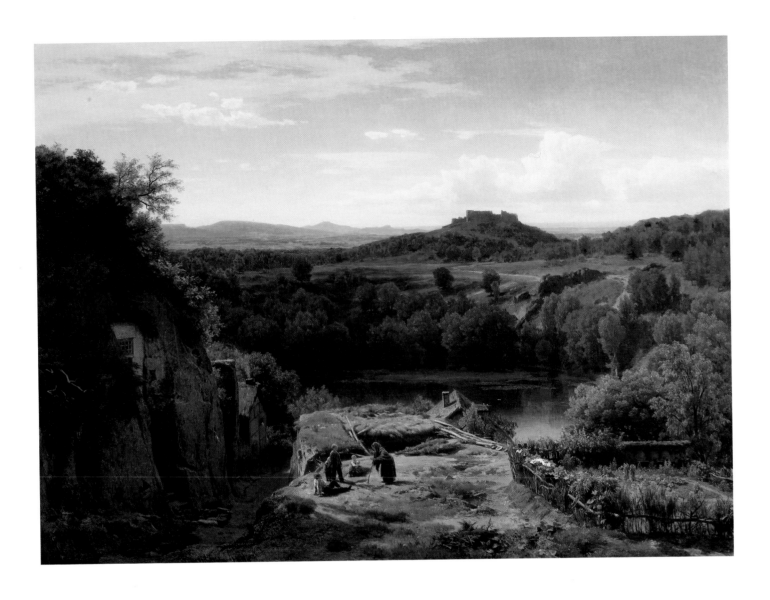

WORTHINGTON WHITTREDGE
American, 1820-1910

Landscape in the Harz Mountains, 1854
Oil on canvas
46⅝ x 63⅜ inches (118.4 x 161 cm)
Gift in memory of Howard R. Peevy from his wife, 73.50

The subject of this landscape is the Harz Mountains near Langenfeld in Germany. Whittredge, who was raised on a farm in Ohio, was largely self-taught until he went to Germany to study at the Düsseldorf Academy in 1849. Even then, his formal education was limited, and he learned chiefly through emulating the work of such painters as Karl Friedrich Lessing and Johann Wilhelm Schirmer. Whittredge made the sketches for this work while accompanying Lessing on a summer tour of the Harz Mountains in 1852. The painting's exquisite details and anecdotal elements enliven the romantic landscape.

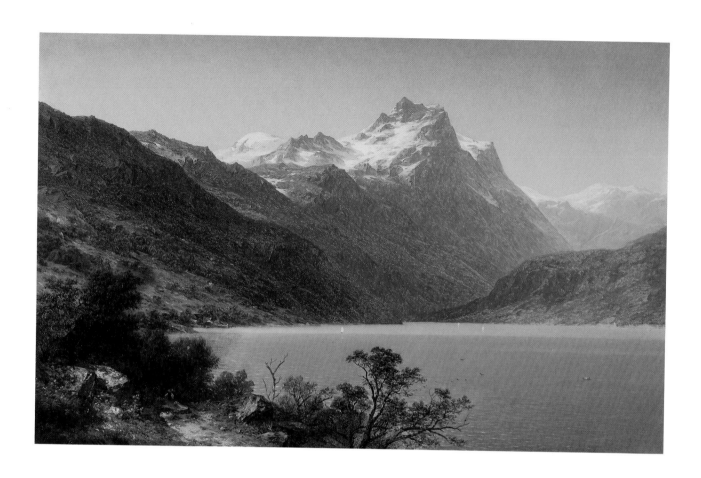

John William Casilear
American, 1811-1893

Alpine Lake Landscape, 1860
Oil on canvas
19 x 30⅛ inches (48.3 x 76.5 cm)
Gift of Dorothy Smith Hopkins in memory of her parents, Nannette Carter Smith and James Allen Smith, 1983.2

In 1840 Casilear travelled to Europe with his friend and teacher Asher B. Durand and his fellow artists John F. Kensett and Thomas P. Rossiter. It was on this trip that Casilear was first struck by the magnificence of Alpine scenery. In 1857 Casilear and Durand returned to Europe, where they spent two years sketching and painting, and studying the old masters. Like Durand's works, Casilear's paintings have a meticulous finish, evidence of his early training as an engraver. Casilear learned from Durand to paint directly from nature, taking paint and canvas into the open. A delicacy and a silvery tonality underscore the tranquility of his landscapes. In 1867 the historian Henry T. Tuckerman wrote: "The habit of dealing strictly with form gives a curious correctness to the details of [Casilear's] work; there is nothing dashing, daring, or off-hand; all is correct, delicate, and moral."

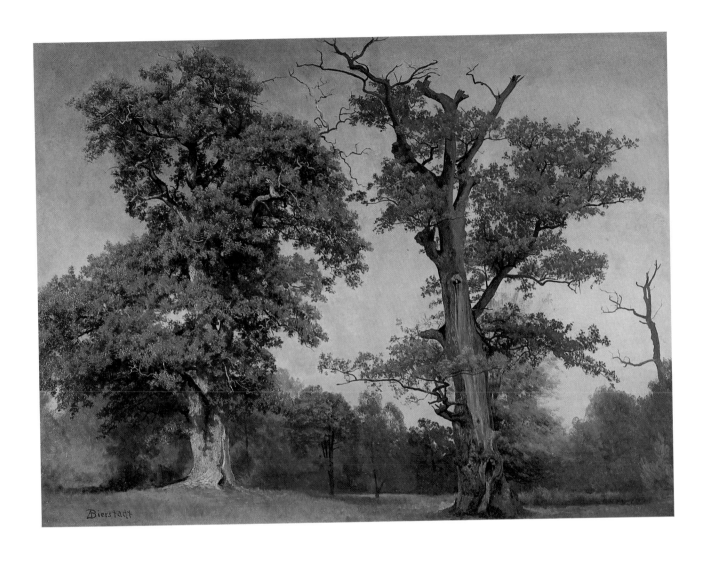

ALBERT BIERSTADT
American, 1830-1902

*Pioneers of the Woods,
California*, ca. 1863
Oil on canvas
19⅛ x 25⅞ inches (48.6 x 65.7 cm)
Gift of the Exposition Foundation,
71.27

While studying art at the Düssel-
dorf Academy, Bierstadt adopted
the practice of making pencil draw-
ings and oil sketches which he later
used to compose spectacular large
landscapes. Although this work
appears to be very detailed and
finished, it is an oil study for a
larger work. It was probably made
during Bierstadt's 1863 trip to the
Yosemite Valley in California. In a
land without ancient ruins or
monuments, ancient trees sym-
bolized America's antiquity. These
gnarled, weather-beaten oaks are
typical of those found along the
Tuolumne River.

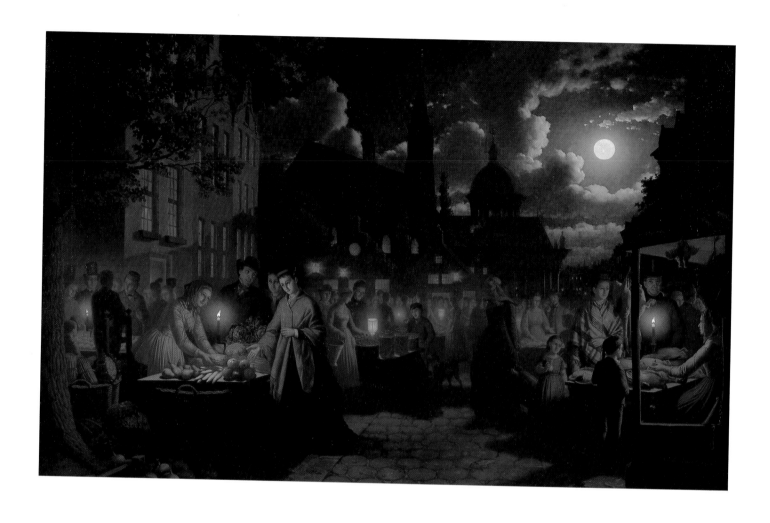

JOHANN MONGELS CULVERHOUSE
Dutch, active in America 1849-1891

Moonlit Market, 1874
Oil on canvas
23⅞ x 38 inches (60.6 x 96.6 cm)
Gift of the James Starr Moore
Memorial Foundation, 1985.20

Culverhouse was born in Rotterdam, studied art at the Düsseldorf Academy, and immigrated to America in the mid-nineteenth century. He was an active landscape and genre painter in New York City from 1849 to 1891. Night scenes with more than one light source were his hallmark. In this he was undoubtedly influenced by Caravaggio, the Italian master of chiaroscuro, and the French master Georges de la Tour. *Moonlit Market* depicts an open air market in Albany, New York. The full moon and the candles in the market shops provide dramatic lighting effects.

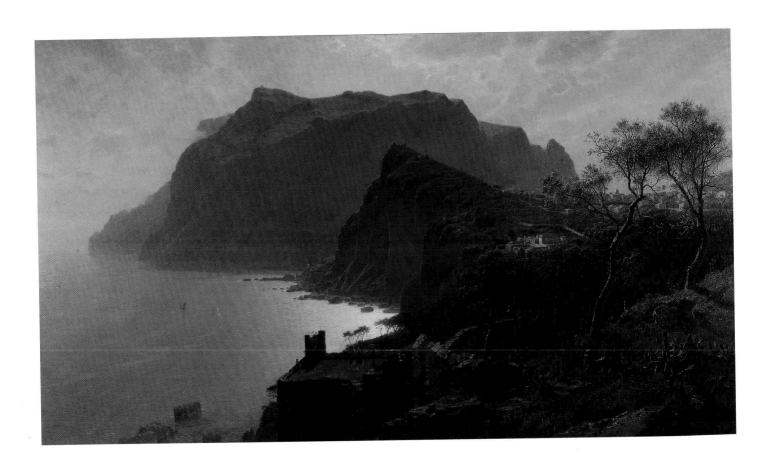

WILLIAM STANLEY HASELTINE
American, 1835-1900

The Sea from Capri, 1875
Oil on canvas
41¼ x 72⅞ inches (104.8 x 185.2 cm)
Purchase with funds from the
Members Guild in honor of Mrs.
Wilbur Warner, President (1982-83)
of the Members Guild, 1982.321

Born in Philadelphia in 1835,
Haseltine studied with the German
trained artist Paul Weber. In 1854
he went to Düsseldorf for further
study, where he associated with
the older artists Emanuel Leutze,
Worthington Whittredge, and
Albert Bierstadt. He returned to
America for a short time, and then
lived in Paris briefly before moving
permanently to Rome in 1867. This
Italian landscape shows the scru-
pulous attention to detail which
Haseltine had learned at the
Düsseldorf Academy, coupled with
an interest in rendering light and
atmosphere as he explores the lam-
bent reflection of sunset against
the ancient buildings of Capri.

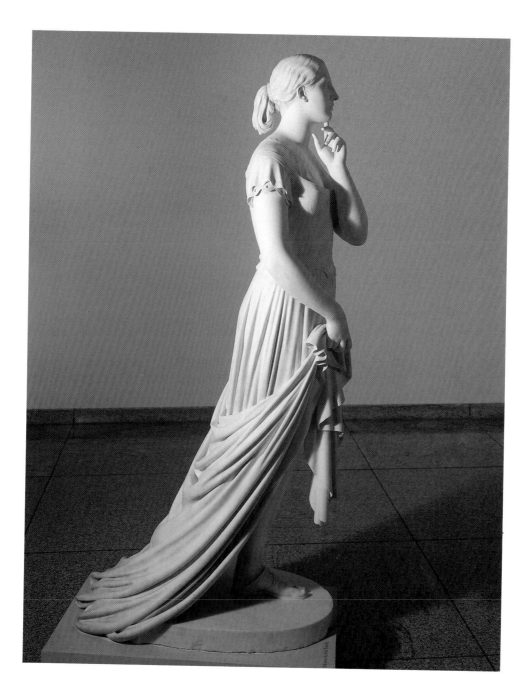

HIRAM POWERS
American, 1805-1873

La Penserosa, 1856
Marble
74½ inches (189.2 cm) high
Lent by the West Foundation,
EL 139.1986

As an adolescent, Powers moved
with his family from Woodstock,
Vermont, to Cincinnati, Ohio,
where he learned to model in clay
from the sculptor Friedrich
Eckstein. From 1834 to 1837 he
received commissions that enabled

him to move permanently to Italy.
La Penserosa was inspired by the
description of the goddess of mel-
ancholy in John Milton's poem *Il
Penseroso*, composed around 1632:

Come, pensive nun, devout and
 pure
Sober, steadfast and demure
All in a robe of darkest grain,
Flowing with majestic train,
And sable stole of cypress lawn
Over thy decent shoulders drawn.
Come; but keep thy wonted state,
With ev'n step, and musing gait,

And looks commercing with the
 skies,
Thy rapt soul sitting in thine eyes:
There, held in holy passion still,
Forget thyself to marble, till
With a sad leaden downward cast
Thou fix them on the earth as fast.

This is the only version of *La
Penserosa* known to have been pro-
duced. A smaller version was
begun by Powers in the 1850s, but
the block broke during carving and
was destroyed.

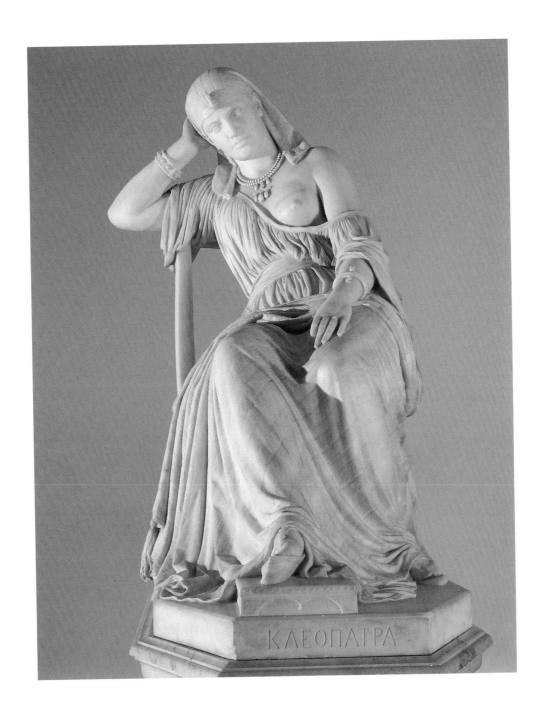

WILLIAM WETMORE STORY
American, 1819-1895

Cleopatra, 1878
Marble
54⅝ inches (138.7 cm) high
Acquired in memory of George and
Elma West and Arthur and Eunice
Eichenlaub for the West Founda-
tion by their grandchildren,
EL 149.1986

The son of a Supreme Court
Justice, Story was a Harvard Law
School graduate and a gifted intel-
lectual. When he went to study

sculpture in Rome, his wealth, con-
nections, and literary talents soon
placed him at the center of the
American artists' colony there.

It was *Cleopatra*, first conceived
in 1858, that attracted interna-
tional attention to Story, in part
because of Nathaniel Hawthorne's
description of the statue in his
story *The Marble Faun*. Story's
Cleopatra was sent, at the expense
of Pope Pius IX, to the 1862 Inter-
national Exposition in London,

where it created a sensation. This
replica was commissioned by the
Goldsmith Guild in London.

It is difficult to see in this impas-
sive, remote figure the "fierce,
voluptuous, passionate, tender,
wicked, terrible, and . . . terribly
dangerous woman" described by
Hawthorne, "quiet enough for the
moment, but very likely to spring
upon you like a tigress."

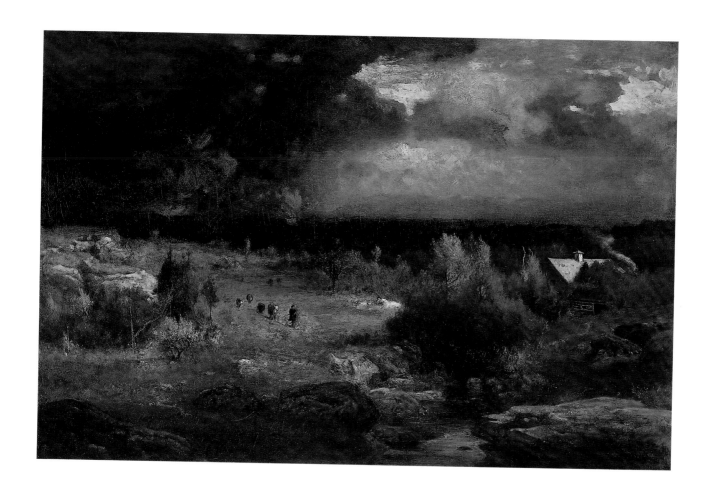

George Inness
American, 1825-1894

Clearing Up, ca. 1875
Oil on canvas
20¼ x 30 inches (51.5 x 76.2 cm)
Purchase through exchange and a
gift of Benjamin Elsas in memory
of Matilda Reinhardt Elsas, 75.52

Inness studied first with the Hudson River School artists, but soon fell under the influence of the Barbizon School and Impressionist artists in Europe. As his style evolved, landscape became a vehicle for his poetic vision. *Clearing Up* was painted around 1875 – the mid-point of Inness's career. He had returned from his third European trip a year earlier and had spent the summer in Conway, New Hampshire, amid the breathtaking scenery of the White Mountains. This work depicts the clearing of black skies after a summer storm. The open, free brushwork and rich palette are evidence of European influences. Approaching storms and clearing skies appeared often in Inness's landscapes as symbols of life's turmoil and the tranquility of resolution.

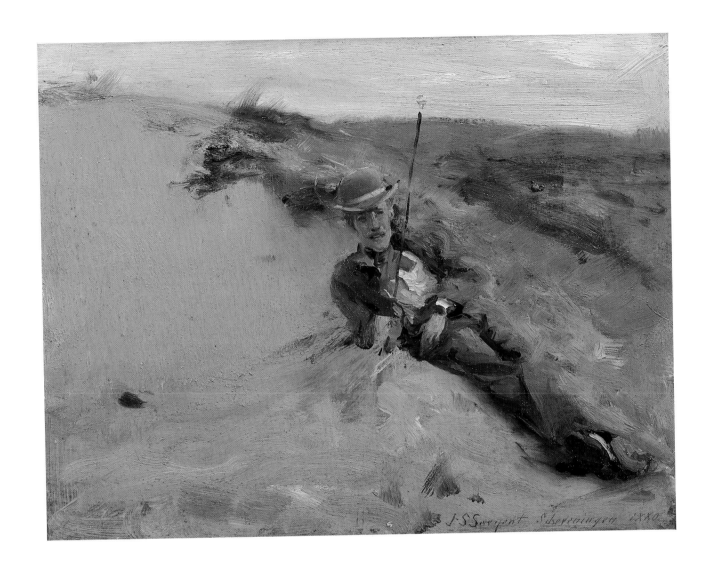

JOHN SINGER SARGENT
American, 1856-1925

Portrait of Ralph Curtis on the Beach at Scheveningen, 1880
Oil on wood panel
10½ x 13⅞ inches (26.7 x 35.3 cm)
Gift of the Walter Clay Hill and Family Foundation, 73.3

John Singer Sargent enjoyed an international reputation as a portrait painter in the decades around the turn of the century. This portrait of his cousin, fellow artist, and lifelong friend Ralph Curtis was painted in 1880, while the two were on a trip to Holland to study the work of Frans Hals. With rapid, free brushstrokes, Sargent depicts Curtis casually posed on the dunes near Haarlem. Grains of sand are caught in the oil paint, making it likely that the portrait sketch was done on the site.

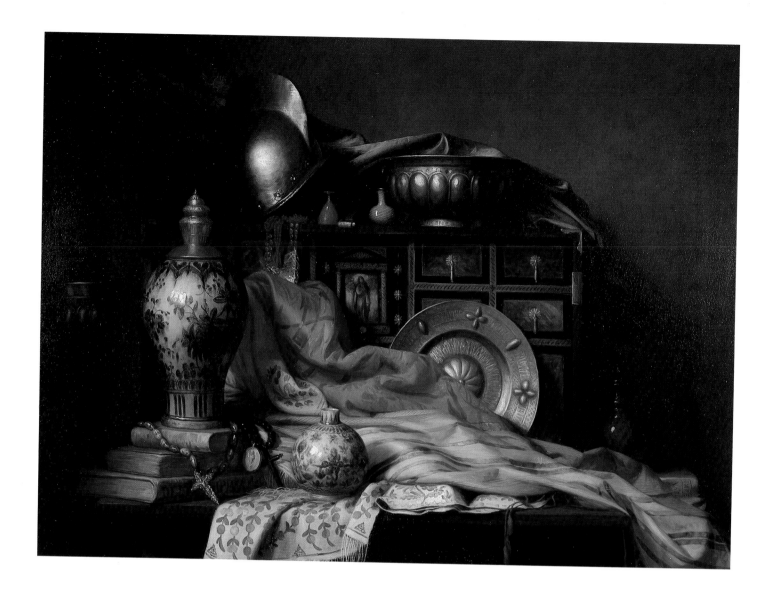

GEORGE HENRY HALL
American, 1825-1913

*Bric-à-Brac from Damascus,
Rome, and Seville*, 1880
Oil on canvas
35 x 47⅞ inches (88.9 x 121.6 cm)
Lent by the West Foundation,
EL 21.1981

George Henry Hall, one of the best
late nineteenth-century American
still life painters, studied at the
Royal Academy in Düsseldorf in
1849, and then lived in Paris before
returning to America in 1852. His
painting was commercially success-
ful, enabling him to live in Spain
from 1860 until 1865. During this
period he also made excursions to

Egypt and Italy.

Many of Hall's still lifes were
small, simple fruit and flower
arrangements in natural settings
advocated by the English aestheti-
cian John Ruskin. But in *Bric-à-
Brac from Damascus, Rome, and
Seville*, exotic and antique objects
are arranged in an elaborate artifi-
cial display. Oriental porcelains
and old books are artfully placed
atop a southern European cabinet.
A brass charger, melon-shaped
bowl, and soldier's helmet are
dramatically lit to reflect a golden
light; highlights also flicker on the
surface of Venetian glass. Colorful

silks, damasks, and embroideries
add to the opulence of textures. A
critic in *The Independent* (June 2,
1881) called this painting Hall's
"most noteworthy picture in the
Academy Exhibition . . . a color
composition of great richness."

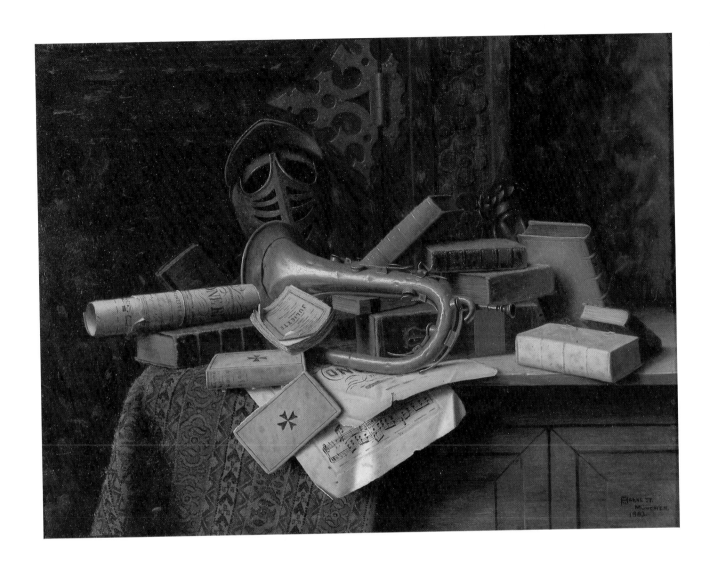

WILLIAM MICHAEL HARNETT
American, 1848-1892

Still Life: Helmet, Books,
Trumpet, and Sheet Music, 1883
Oil on wood panel
10¼ x 13¾ inches (26.1 x 35 cm)
Gift of Mr. and Mrs. James M.
Dyer and Mr. and Mrs. Truman
Bragg in memory of Mrs. Mary
Newcomb Bull and Robert Scott
Newcomb, 64.27

Harnett continued the tradition of
realism in American art estab-
lished by James and Raphaelle
Peale at the beginning of the nine-
teenth century. *Trompe l'oeil* ("fool
the eye") paintings of astonishing
realistic illusion were Harnett's
specialty. He began his career as a
silver engraver, learning to work
with great technical control. After
several years at the Pennsylvania
Academy of the Fine Arts and the
National Academy, Harnett went
to Europe for further study. This
still life was painted in Munich,
where he had become acquainted
first-hand with seventeenth-cen-
tury Dutch painting. The carefully
composed panel shows a battered
trumpet, worn sheet music, a bust
of Dante, and dog-eared leather-
bound books – objects that might
have been found in an educated
gentleman's study.

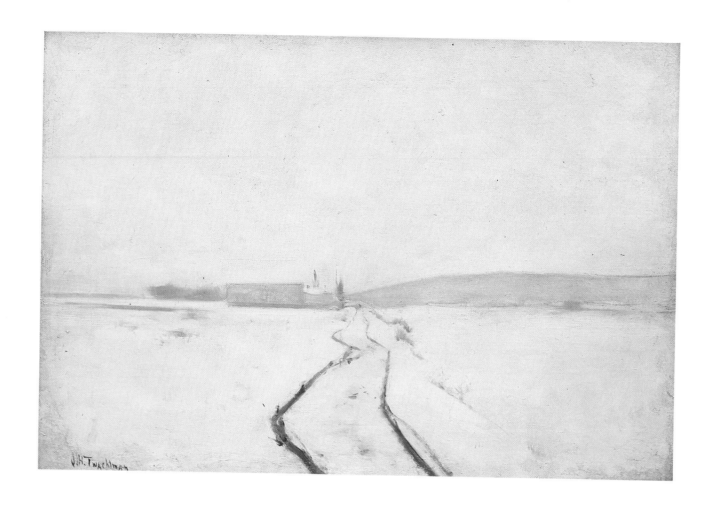

John Henry Twachtman
American, 1853-1902

Along the River, Winter, ca. 1889
Oil on canvas
15¼ x 21⅝ inches (38.8 x 55 cm)
J. J. Haverty Collection, 49.28

On Twachtman's farm near Green-wich, Connecticut, a stream wound through rocky land and tumbled over a waterfall into a large basin called Hemlock Pool. Twachtman's snow scenes of this location are studies in color and design which do not record detail but show the artist's understanding of the poetic power of an abstract composition to evoke a mood. At this point in his career, Twachtman had aban-doned the dark, bravura manner he had developed while studying in Munich, and had not yet fully assimilated the spontaneous approach of the French Impres-sionists. *Along the River, Winter* reveals that he shares Monet's liking for winter scenes and Whistler's interest in the designs of Japanese prints. The freely painted, uneven tracks in the snow, leading from the front edge back to the vague shapes in the distance, create an air of tension and mys-tery that marks this painting as one of Twachtman's most original works.

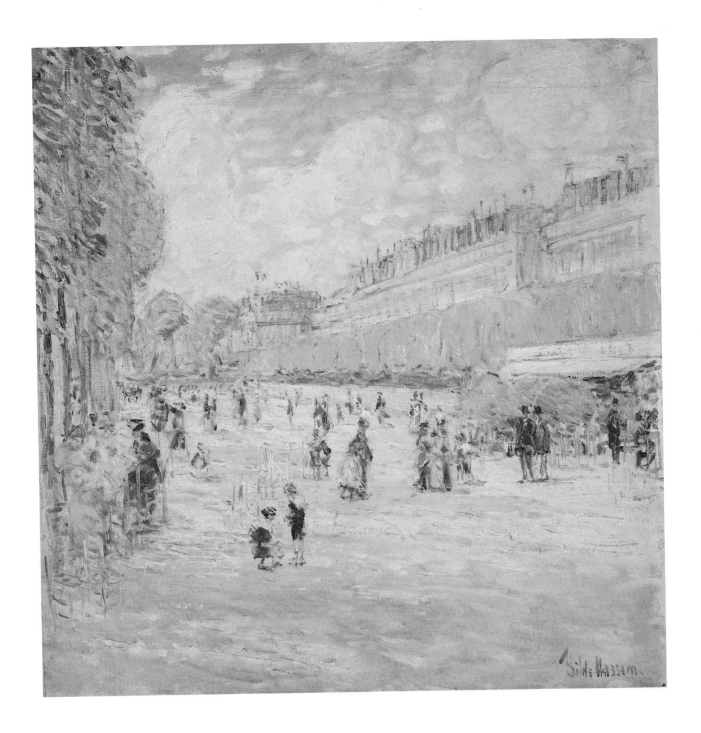

CHILDE HASSAM
American, 1859-1935

Tuileries Gardens, ca. 1897
Oil on canvas
24⅛ x 24⅛ inches (61.3 x 61.3 cm)
Gift of Mary E. Haverty for the
J. J. Haverty Collection, 61.66

In 1898 Hassam and John Henry Twachtman founded the group of American Impressionists known as "The Ten." This painting was probably done on Hassam's third trip to Paris in 1897, when his mature Impressionist style emerged. The influence of the French Impressionists Monet, Sisley, and Pissarro is clearly evident in Hassam's free use of color. The dramatic perspective and bold impasto brushwork were Hassam's own inventions and became trademarks of his style. This scintillating view of the Tuileries Gardens captures the joyous bustle of a sunny afternoon in Paris.

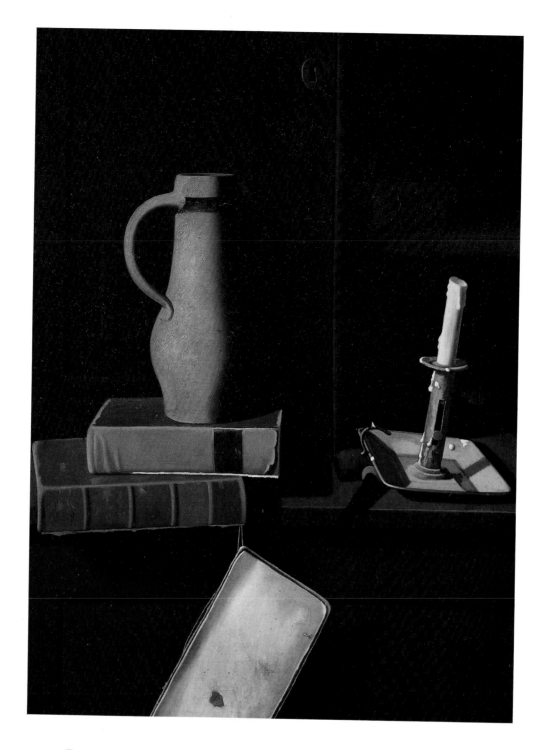

JOHN FREDERICK PETO
American, 1854-1907

Still Life, ca. 1890
Oil on canvas
29⅞ x 22 inches (76 x 55.9 cm)
Gift of Julie and Arthur
Montgomery, 1980.60

Little known during his lifetime, much of Peto's work has only recently been discovered. Born in Philadelphia, Peto studied briefly at the Pennsylvania Academy of Fine Arts, but was largely self-taught. He was greatly influenced by William Harnett, whom he met between 1876 and 1880. Like Harnett, he borrowed images from the Dutch Masters and devoted his efforts to *trompe l'oeil* painting. In this still life, Peto evokes the *vanitas* theme: the snuffed-out can-dle, the cold pipe, and the worn bookcover hanging by a thread symbolize the vanity of human endeavors. The sense of imperma-nence is emphasized by the precar-ious placement of the objects. The images remind us that the pleas-ures and attainments of life are transitory.

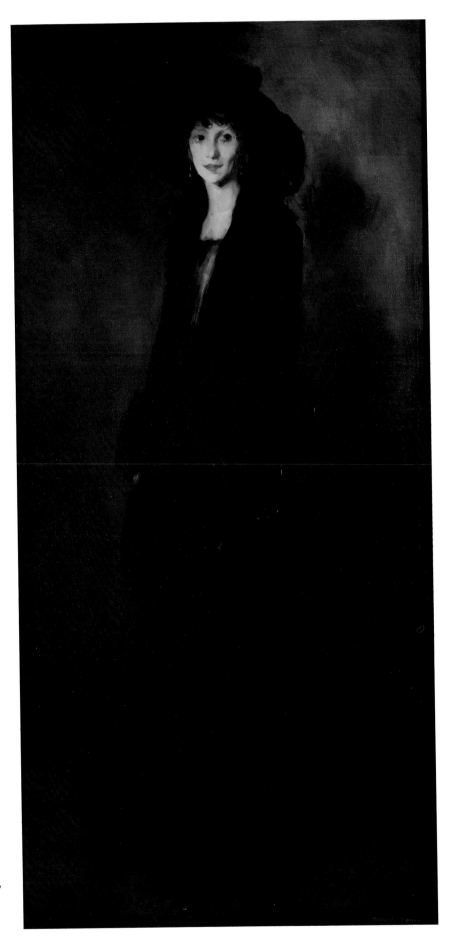

ROBERT HENRI
American, 1865-1929

*Lady in Black Velvet (Mrs.
Eulabee Dix Becker)*, 1911
Oil on canvas
77⅛ x 36⅞ inches (195.9 x 93.7 cm)
Gift in memory of Dr. Thomas P.
Hinman through exchange and
general funds, 73.55

Robert Henri was known for his
direct and honest realism. The sub-
ject of this portrait was his fellow
painter Mrs. Eulabee Dix Becker.
The severely restricted palette of
black and white, the broad, loaded
brushwork, and the dramatic nar-
row format capture the viewer's
attention. Mrs. Becker's fashion-
able attire, with plunging neckline,
oversized black hat, and drop ear-
rings, mark her as a woman of the
new century.

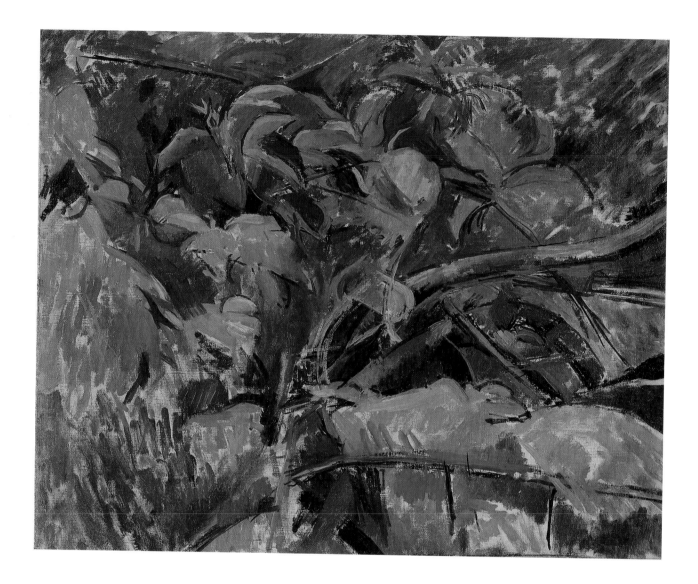

PATRICK HENRY BRUCE
American, 1881-1936

Leaves, ca. 1912
Oil on canvas
17¼ x 21½ inches (43.8 x 54.6 cm)
Gift of Margaret and Rhodes
Perdue through the 20th Century
Art Acquisition Fund, 1986.6

Bruce and many other American artists, including Stuart Davis, Stanton Macdonald-Wright, and Max Weber, journeyed to Paris as a matter of course to complete their studies. There they dis- covered that the works of the Post-Impressionists were revolu- tionizing the way artists looked at the world. Cézanne and Matisse rejected Impressionism as mere representation and sought an expressive design imbued with personal vision. Bruce studied Cézanne's pictorial structure and technique for three years after becoming a member of Matisse's school in Paris in 1908. *Leaves* was one in a series of foliage close-ups painted in the summer of 1912, its sources lying in Cézanne's formal structure and in Matisse's color harmonies. Bruce's later works— flat hard-edged still lifes influ- enced by Robert Delaunay—are grounded in his early studies of Cézanne.

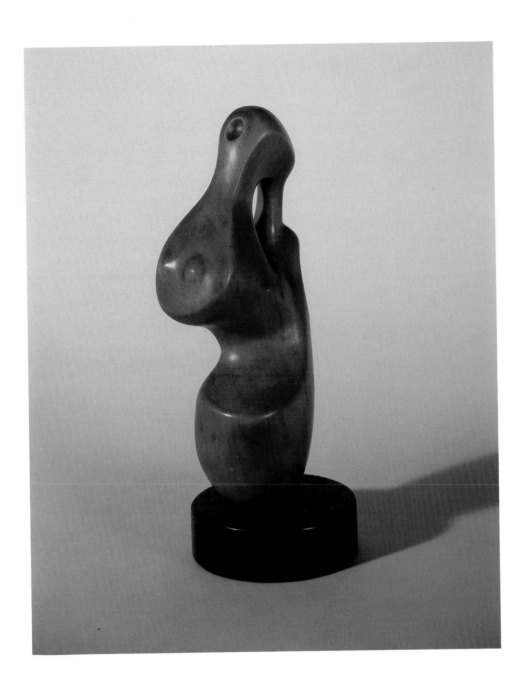

HENRY MOORE
English, 1898-1986

Composition, 1932
Beechwood
14 x 4⅛ x 6⅜ inches
(35.6 x 10.5 x 16.2 cm)
Gift of Rich's, Inc., 1952.18

In this early sculpture Henry
Moore combined his favorite theme
of the female figure with a new
interest in organic abstraction
inspired by Surrealism. Since his
student years at the Royal College
of Art in London in the 1920s

Moore had sculpted the female fig-
ure. By the 1930s he had assimi-
lated both Constantin Brancusi's
methods of direct carving and
Alexander Archipenko's use of
space-forms. *Composition*
transforms these influences in a
biomorphic abstraction probably
inspired by Picasso's surrealistic
works, which Moore had seen illus-
trated in the French art magazine
Cahiers d'art.

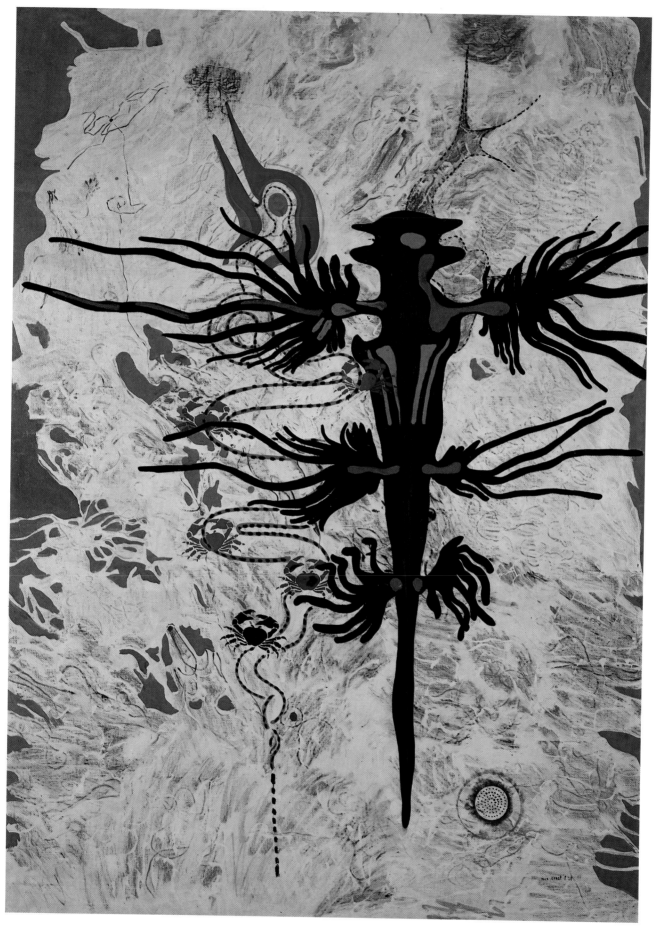

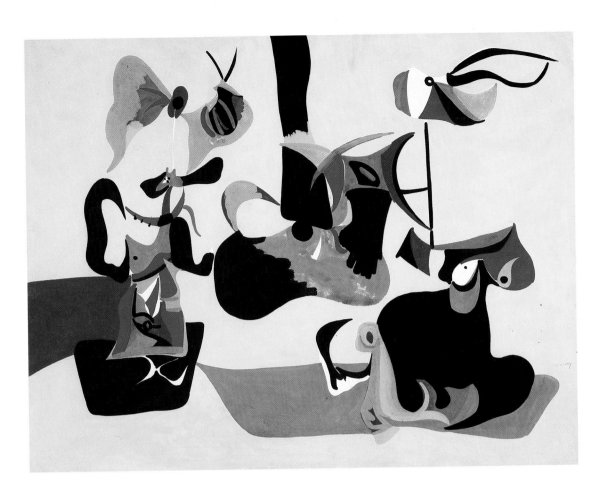

MAX ERNST
German, 1891-1976

Tree of Life, 1928
Oil on canvas
114¼ x 82¾ inches (290.2 x 210.2 cm)
Purchase with funds given by
Alfred Austell Thornton in memory of Leila Austell Thornton and
Albert Edward Thornton, Sr., and
Sarah Miller Venable and William
Hoyt Venable, 1983.92

In this unusually large canvas,
Ernst evokes a surreal, underwater world inhabited by creatures
both recognizable and imaginary.
Ernst, like other Surrealists in
Paris in the 1920s, aimed to destroy
traditional values by dispensing
with the outside world as a model
and drawing upon the subconscious. Through strange juxtapositions of unrelated objects, and
through the use of improvisational
methods like "frottage" (the rubbing of surfaces to create textures,
as seen here), Ernst invented new
worlds.

ARSHILE GORKY
American born in Armenia,
1905-1948

Garden in Sochi, 1940-41
Gouache on board
21 x 27¾ inches (53.3 x 70.5 cm)
Purchase with bequest of
C. Donald Belcher, 1977.50

In *Garden in Sochi*, Gorky drew
upon his childhood memories of
Armenia and an abstract biomorphic language inspired by the
works of Joan Miró. Stimulated by
the Surrealists' emphasis on subjects drawn from dreams and the
subconscious, Gorky conveyed his
remembrances of villagers visiting
his father's garden, a local shrine
known as the Garden of Fulfillment. On the left he indicated the
garden's magic blue rock, and in
the upper right corner is a trace of
the fluttering strips of cloth the villagers attached to the garden's big
poplar tree (an Armenian custom).
According to Gorky, the central
image was inspired by an oldfashioned butter churn.

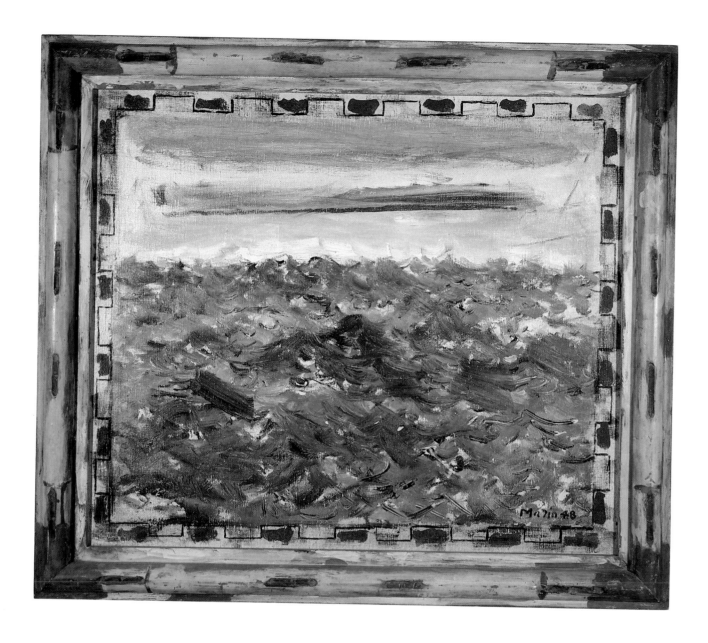

JOHN MARIN
American, 1870-1953

Sea, Light Red and Cerulean Blue, 1948
Oil on canvas, painted wood frame
24½ x 29¼ inches (62.3 x 74.3 cm)
Purchase with bequest of
C. Donald Belcher, 1977.48

Like many others, John Marin travelled to Europe to complete his art training. However, it was only after he returned to New York in 1910 that he encountered Futurism and other modern movements, which probably prompted his visual evocations of movement and energy. Marin became a pivotal member of the avant-garde group around Alfred Stieglitz, who introduced modern art to the American public through his gallery 291 and his magazine, *Camera Work*.

The turbulences of the sea and city transferred to paper and canvas became a lifelong passion for Marin. His works were always based on nature, as he made clear: "The sea that I paint may not be *the* sea, but it is *a* sea, not an abstraction." In the early 1920s, he began to integrate the frame with the work – applying pigment to the frame itself and painting a frame on the canvas or paper.

54

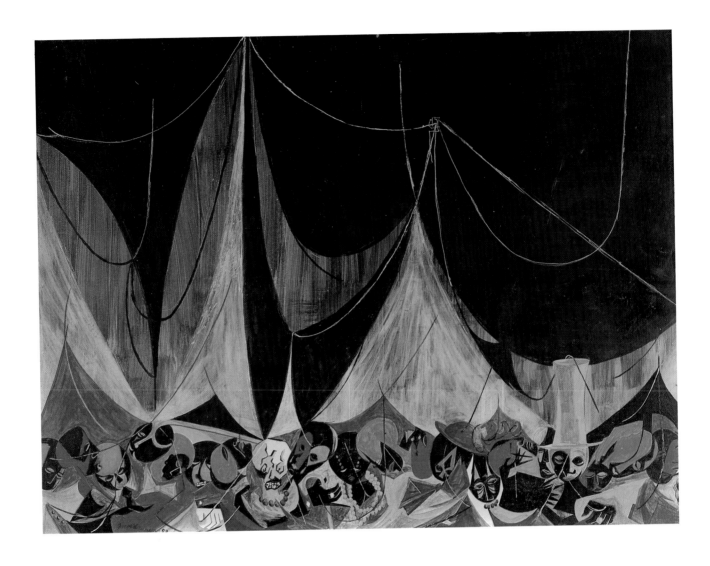

JACOB LAWRENCE
American, born 1917

Marionettes, 1952
Tempera on gesso panel
18¼ x 24½ inches (46.4 x 62.2 cm)
Purchase with funds from Edith G.
and Philip A. Rhodes and the
National Endowment for the Arts,
1980.224

Marionettes, painted in 1952, is one
of a series of pictures inspired by
Harlem theaters, particularly the
Apollo, where Lawrence often
went as a youth during the Depres-
sion. Lawrence's love for the
"magic" of theater comes through
in his lively band of marionettes
jostling for space beneath a heavy
billowing stage curtain. The psy-
chological effect of theatre is
reflected in the looming curtain's
imminent fall upon the helpless fig-
ures below. This painting, one of
Lawrence's more abstract works,
reflects the influence of both
Cubism and primitive art on his
work during the 1950s and 1960s.
Lawrence gained early critical
attention during the late 1930s
with his straightforward scenes of
black life and history.

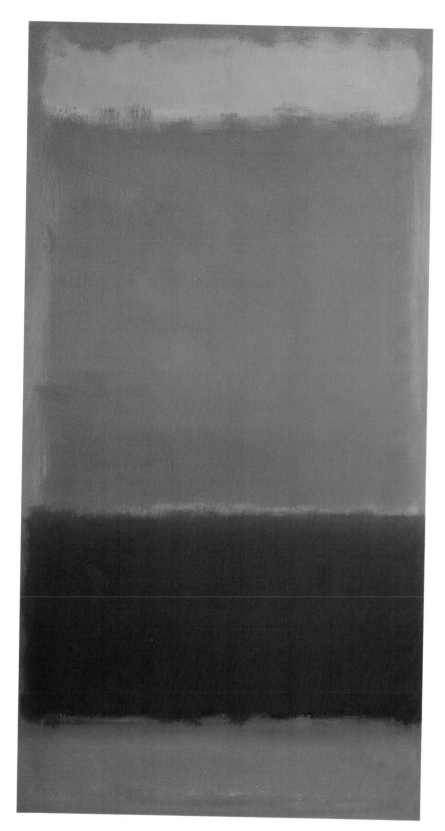

MARK ROTHKO
American, 1903-1970

Number 73, 1952
Oil on canvas
55⅜ x 30⅜ inches (140.7 x 77.2 cm)
Gift of The Mark Rothko Foundation, Inc., 1985.27

For the Abstract Expressionists, primitive art and mythology offered universal subjects, and Surrealism suggested new ways of generating images. From these evolved Mark Rothko's philosophy of "expressing basic human emotions – tragedy, ecstasy, doom." Rothko's search in the late 1930s for a new artistic language was inspired by Karl Jung's notion of the collective unconscious. In order to reveal the unconscious through archetypal images, Rothko used the technique of automatism, letting spontaneous images reveal themselves as his hand wandered across the canvas or paper.

Rothko eventually rejected the use of specific images because he felt they were too limited and finite. Instead, he evolved his signature style of glowing and hovering fields of color. Developed fully in 1949, Rothko's expansive use of color inspired color-field painters of the 1960s, who were interested in pure color and form.

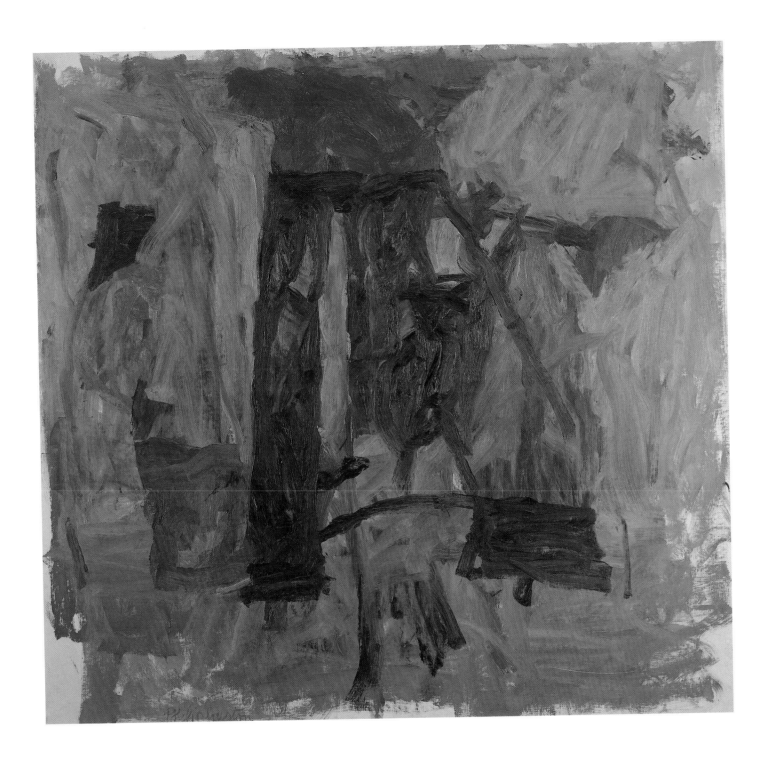

PHILIP GUSTON
American, 1913-1980

The Painter, 1959
Oil on canvas
65 x 69 inches (165.1 x 175.3 cm)
Purchase with funds from the
National Endowment for the Arts
and general funds, 1974.118

A "gestural" Abstract Expression-
ist during the 1950s and 1960s,
Guston, like Jackson Pollock and
Willem de Kooning, saw his large
canvases as arenas in which to act,
and as records of spontaneous and
improvised gestures. Guston
began a painting with no precon-
ceived images in mind—he sought
to create new marks, new life on
canvas. Many of Guston's abstrac-
tions embody representational
associations, however—such as *The*
Painter, which evokes a painter
and easel—and in his late works he
returned to the use of distinct,
recognizable imagery.

Sensitive and energetic brush-
strokes of grays and pinks here do
battle with reds, greens, and blues.
Unlike Pollock's and de Kooning's
aggressive marks, Guston's are lyr-
ical, sensuous, and atmospheric.

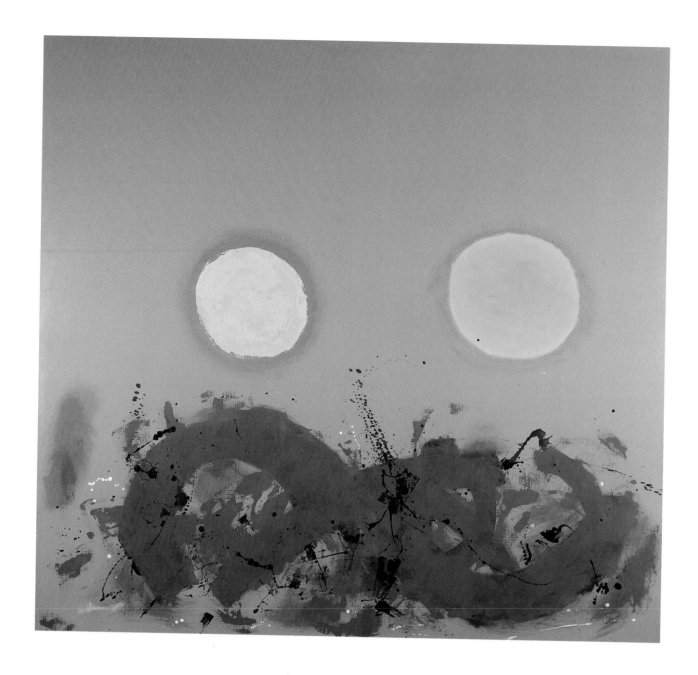

ADOLPH GOTTLIEB
American, 1903-1974

Duet, 1962
Oil on canvas
84 x 90 inches (213.4 x 228.6 cm)
Gift of Nelson A. Rockefeller,
1963.2

For Gottlieb and other Abstract Expressionists, myth played an important role in their works of the late 1930s and early 1940s. The artists were searching for symbols to express universal emotions, more powerful pictorial statements than the depictions of objects in Social Realism or the formal exercises of geometric abstraction. Although many gradually discarded primitivistic, mythic imagery, Gottlieb developed and sustained his use of such symbols, as seen here in *Duet*, a painting from his "Bursts" series, which occupied him from 1957 until his death in 1974. Although Gottlieb's signature motifs are often strongly suggestive of landscape elements, he intended his images to evoke general themes, dualities, the conflict of opposites. He combined the gestural—the record of process, as in Pollock and de Kooning—with a concern for color characteristic of the "color-field" paintings of Rothko and Barnett Newman.

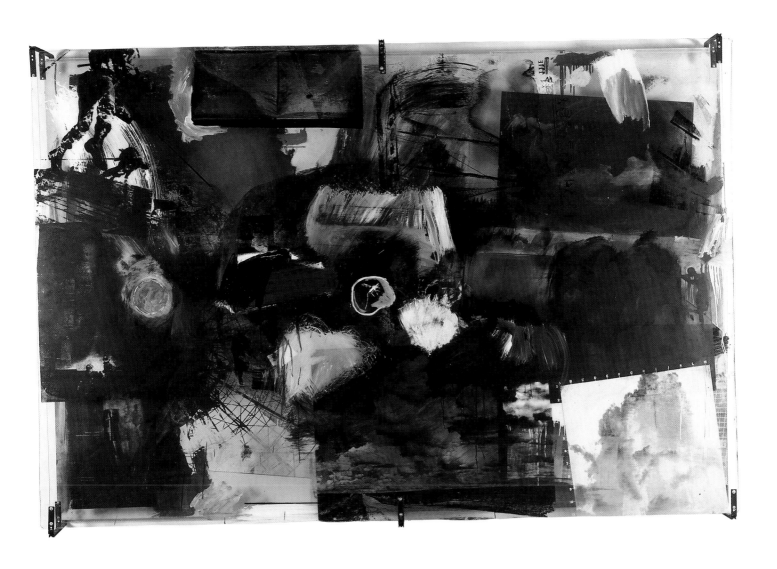

Robert Rauschenberg
American, born 1925

Overcast III, 1963
Oil on canvas and Plexiglas with
silkscreen
71 x 105 x 11 inches
(180.3 x 266.7 x 27.9 cm)
Purchase with funds given by
Alfred Austell Thornton in mem-
ory of Leila Austell Thornton and
Albert Edward Thornton, Sr., and
Sarah Miller Venable and William
Hoyt Venable, 1986.141

Rauschenberg's image-upon-image
approach in *Overcast III* conveys
the simultaneity of the "real"
world. Silk-screened images collide
or hide behind aggressive brush-
strokes on three layers of Plexiglas
and canvas. Rauschenberg, whose
work developed during the heyday
of Abstract Expressionism,
adopted an expressionistic ges-
tural technique and large format
but refused to paint abstractions
because he felt they were too far
removed from everyday life.
Objects such as tires, soda bottles,
and stuffed goats were incorpo-
rated into his sculptures of the
1950s. From these "combine-paint-
ings" (as they were called) came his
silk-screened paintings of the early
1960s, such as *Overcast III*. Here,
forsaking real objects, he substi-
tuted their images. Rauschenberg's
use of popular images, many of
which were derived from magazine
and newspaper illustrations, and
his use of commercial techniques
and materials such as silk-
screening and Plexiglas prefigured
the widespread use of such cultural
references in the art of the late
1960s.

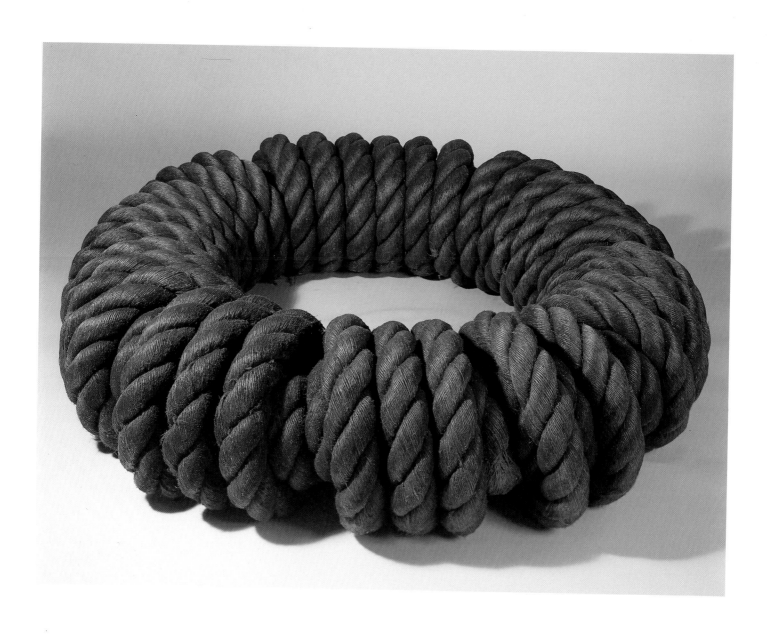

JACKIE WINSOR
Canadian, born 1941

Double Bound Circle, 1971
Hemp
16 x 61 inches in diameter
(40.6 x 154.9 cm)
Purchase with funds from the
National Endowment for the Arts
and the Members Guild, 1980.95

Jackie Winsor's laboriously hand-made sculpture contrasts with the impersonal, often machine-made works of early Minimalist sculptors. Like the Minimalists, she employs simple geometric forms, but her work is unusual in its pre-occupation with the "hands-on" work process, materials such as rope, and naturalistic references:

"What interested me about . . . the rope was that it so stubbornly had its own personality. It really persisted in identifying itself. Its weight and heaviness and, as you pulled it out, its linear quality. Its personality was so strong that I wanted to bring part of me to *it*."

Double Bound Circle's simple form holds in check its muscular strength and complexity and gives a sense of self-containment. Speaking of her rope pieces, Winsor observed, "You relate to them the way you might relate to a sleeping person, to the potential energy that is manifested in a dormant state."

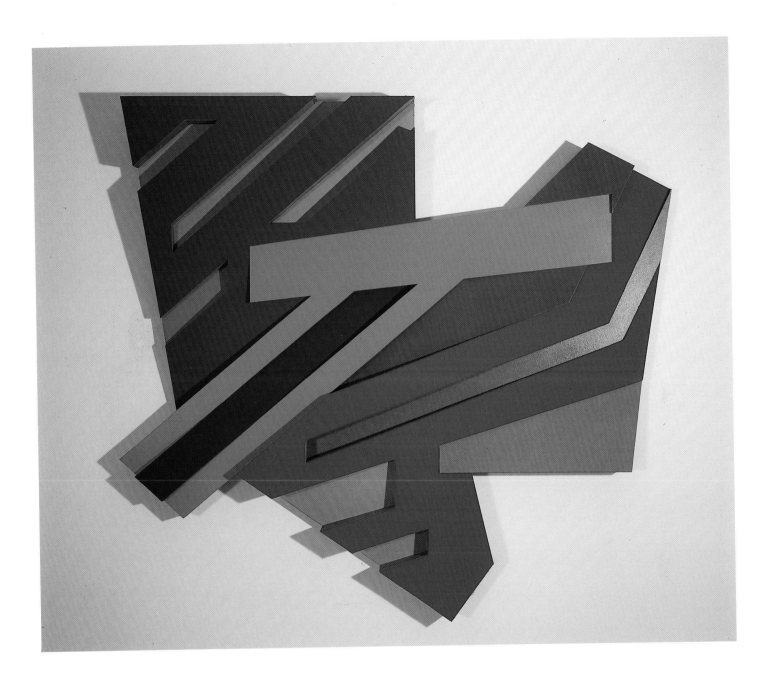

FRANK STELLA
American, born 1936

Warka III, 1973
Mixed media on cardboard
93 x 100 inches (236.2 x 254 cm)
Purchase, 1973.81

Frank Stella has consistently been concerned with the painting-as-object, with no outside references. In 1964, he remarked, "My painting is based on the fact that only what can be seen there *is* there. It really is an object." In the 1960s, his aesthetic inspired the anonymous-looking geometric forms of Minimalist painting and sculpture.

Warka III, like other works done since 1970, is sculptural, complex, and personal. It belongs to a 1973 series of paintings named after Polish towns containing synagogues built in the eighteenth and nineteenth centuries. One writer has suggested that the complex diagonals and angles of these works recall the intricate woodwork of the synagogues.

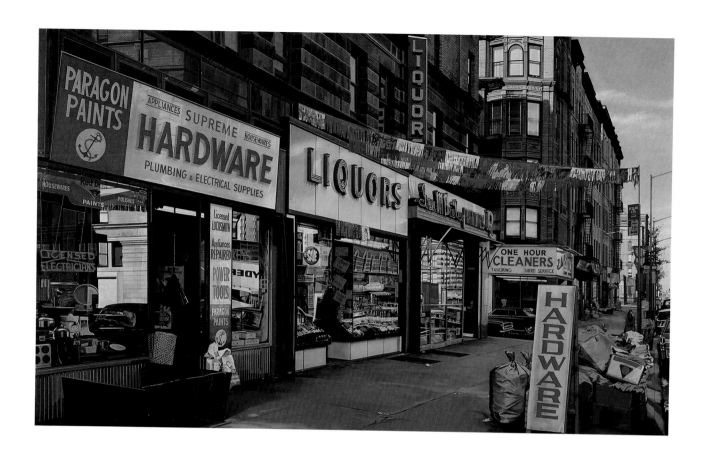

RICHARD ESTES
American, born 1935

Supreme Hardware Store, 1973
Oil and acrylic on canvas
40 x 66¼ inches (101.6 x 168.3 cm)
Gift of Virginia Carroll Crawford,
1978.119

Photo-realist Richard Estes describes his work straightforwardly: "For the past twenty years I've lived in a man-made environment and I've simply painted where I've been. . . . You look around and paint what you see. That's what most painters have done." Estes, however, modifies the cityscape by painting only its outward appearances—its buildings and sidewalks—and almost always eliminates people.

The absence of a narrative in *Supreme Hardware Store* distinguishes Estes from urban realists of the 1930s like Reginald Marsh. Rather, Estes, working from photographs, paints the urban environment, freezes a portion of it, and makes us confront its visual complexities, its reflections and visual cacophony. His polished technique de-emphasizes the artist's individual touch and stresses the impersonal and anonymous character of the large city. Estes makes detailed acrylic sketches from photographs, then painstakingly finishes the work in oils.

ROGER BROWN
American, born 1941

Dawn, 1980
Oil on canvas
78 x 72 inches (198.1 x 182.9 cm)
Purchase with funds from the
National Endowment for the Arts
and the Members Guild, 1980.78

Born in Opelika, Alabama, and
trained at the School of the Art

Institute of Chicago, Roger Brown
combines narrative with stylized
forms and rhythmic patterns. He is
identified with a group of Chicago
painters who employ satirical and
popular motifs which recall folk art
and cartoons.

In *Dawn*, a rising sun apparently
overwhelms a landscape marked

by tractors, fields, and city build-
ings. Symmetry and repetition
usually neutralize Brown's sub-
jects, which are often depictions of
disasters, from earthquakes to
nuclear explosions. With this in
mind, *Dawn*'s life-giving sun
assumes ominous connotations.

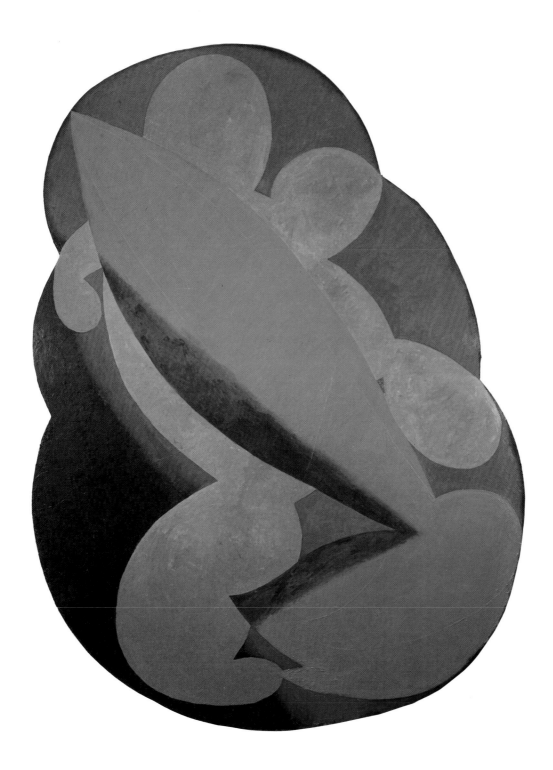

Elizabeth Murray
American, born 1940

Brush's Shadow, 1981
Oil on canvas
116 x 86½ inches (294.7 x 219.7 cm)
Gift of Frances Floyd Cocke,
1981.54

Elizabeth Murray's shaped and segmented canvases incorporate references to natural forms, con- ventions of still life painting, and the traditions of modernism. She does not want her images to be specific to viewers, however: "That's the whole idea of abstraction—that there are no rules." She has remarked that the title *Brush's Shadow* is derived from the central brush-like shape: "My personal association to the back shape is that it's a figure, the central shape a brush, the tool that I use to communicate with." Murray often begins a painting intuitively, wishing to see a certain color or form.

64

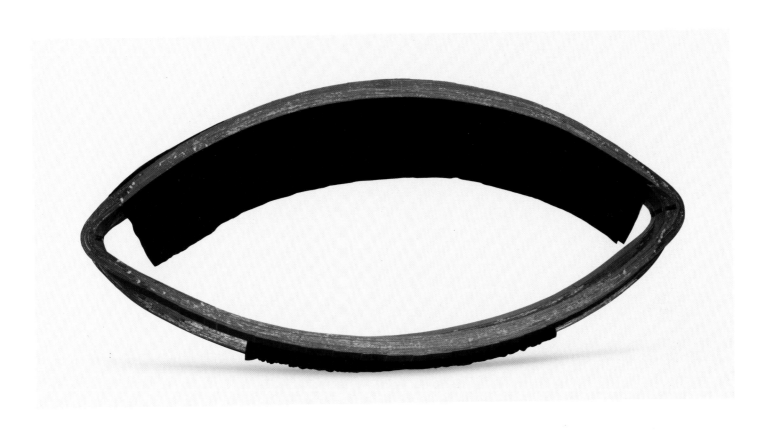

RICHARD DEACON
English, born 1949

Turning a Blind Eye, II, 1985
Masonite and black cloth
66 x 150 x 48 inches
(167.6 x 381 x 121.9 cm)
Purchase with funds from the 20th
Century Art Acquisition Fund,
1985.262

Richard Deacon makes sculpture
using untraditional materials like
masonite, cloth, and glue. Like
many of his British contempo-
raries, Deacon sets his works apart
from the traditional bronze and
steel sculptures of English mod-
ernists Henry Moore and Anthony
Caro through his use of unfinished
materials. Deacon reinvests the
abstract object with allusion and
drama. Many of his sculptures
refer metaphorically to the senses,
although they remain abstract and
evoke multiple and enigmatic ref-
erences. For example, titles of
other Deacon works refer to "deaf
ears."

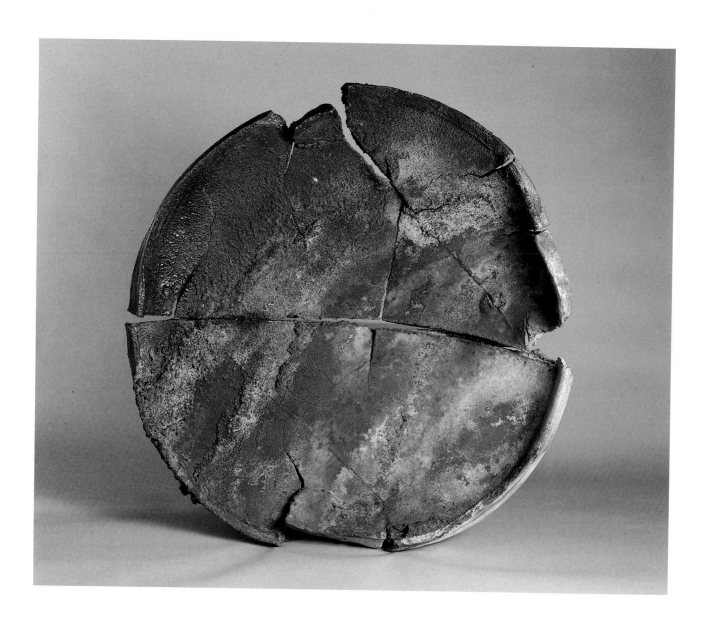

PETER VOULKOS
American, born 1924

Untitled, 1980
Ceramic
24 inches (60 cm) in diameter
Purchase, 1983.94

Originally trained in functional pottery as well as in painting, Voulkos began in the early 1950s to explore innovative uses of surface decoration and coloration, amalgamating the formal vocabulary of pottery with the aesthetic concerns of painting and sculpture (in which he also is active). His radical handling of the clay became increasingly spontaneous and expressionistic after his contact with avant-garde artists while teaching at Black Mountain College in North Carolina in 1953 and his subsequent trips to New York, during which he met Abstract Expressionist painters. Voulkos's dynamic working methods and belief in direct expression carried the use of clay far beyond the confines of established craft traditions.

After a period of working predominantly in large bronze sculpture, Voulkos resumed making abstracted plates in the early 1970s. He freely gouges, punctures, tears, and cracks the object's surface, as in this example, to give these works a coarse, primitivistic appearance, reinforced by their encrusted surfaces and naturalistic color.

HOWARD BEN TRÉ
American, born 1949

Column #31, 1986
Cast glass
99 inches (251.5 cm) high
Purchase for Elson Collection of
Contemporary Glass, with match-
ing funds from Edith G. and Philip
A. Rhodes, 1986.286

Ben Tré's sculpture, though gener-
ally classified as minimalist, evokes
memories of ancient civilizations.
As his cast-glass pieces have
evolved from horizontal format to
vertical, from tabletop size to
human scale, these strange, secre-
tive columns and stelae have been
invested with intimations of forgot-
ten ritual. For all their shimmering
mystery, Ben Tré's glass objects
are cast using industrial tech-
niques in a factory-like situation.
The oxidized, corroded metal
decoration enhances the sense of
remote antiquity. "My intention,"
the artist has written, "is to make
provocative objects."

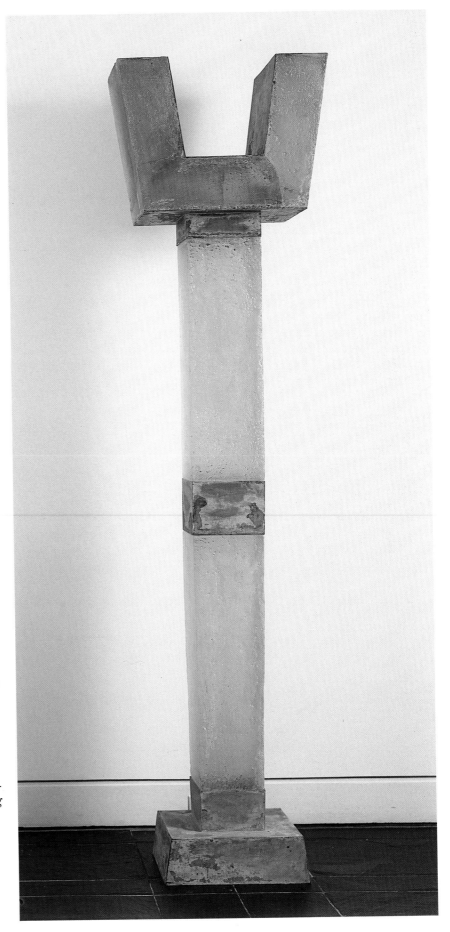

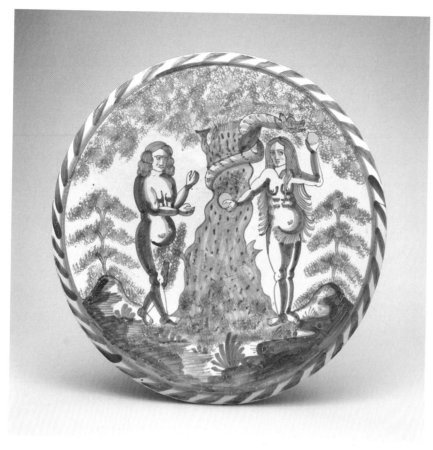

Charger, ca. 1670
Tin-glazed earthenware, lead-glazed back
16 inches (40.7 cm) in diameter
London, probably Lambeth
Emory and Frances Cocke
Collection, 1983.134

Most seventeenth-century English tin-glazed earthenware (or delft-ware) was made for utilitarian purposes. Pictorial chargers, however, were apparently used mainly for decoration. Royal personages, flowers, and Biblical scenes were among the most popular subjects for these ornaments. Adam and Eve chargers were made from at least 1635 until after 1725. On this piece, the cloud-like pointed trees flanking the figures and the sponge decoration suggest a date in the third quarter of the seventeenth century. The high-rimmed base made it possible to secure the charger to the wall with string.

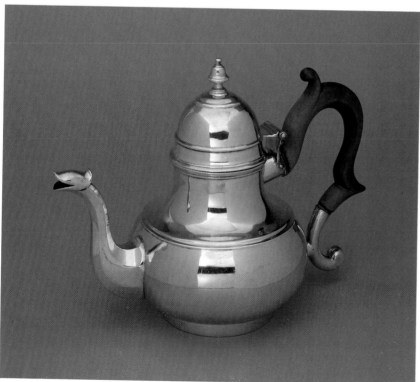

Teapot, ca. 1730
Silver with wooden handle
6¾ x 9¾ inches (17.2 x 24.8 cm)
Thauvet Beasley (ca. 1690-1757),
New York City
Purchase with funds from the Decorative Arts Endowment in honor of Mrs. James T. Roe, III, President (1985-86) of the Members Guild, 1986.48

Thauvet Beasley was born in the colonies, but by 1710 had traveled to London. He seems to have learned his trade in Amsterdam, where he was registered in the guild of silversmiths in 1715. By 1727 Beasley had returned to New York, where he spent the rest of his career. The graceful pear shape of this teapot is characteristic of a group of pots made by silversmiths in New York City during the first third of the eighteenth century. This teapot was not part of a service, but was probably used with other silver, ceramic, and glass wares.

Pair of Tureens and Ladles,
ca. 1755
Porcelain
6 x 7½ x 11¼ inches
(15.2 x 19.1 x 28.6 cm)
Lawrence Street Factory
(ca. 1745-1770), Chelsea, England
Emory and Frances Cocke
Collection, 1984.56.1 and 1984.56.2

Animal forms were among the most whimsical tablewares produced by the English porcelain factories during the eighteenth century. Possibly intended to hold fish sauce, these tureens are in the form of plaice (flatfish). The tureens appear to be swallowing the ladles, which are shaped like smaller fish. The Chelsea factory often sold its wares in London by auction, and the 1756 catalogue lists "a beautiful pair of plaice sauce boats with spoons and plates." Other examples with stands but missing the ladles are in the Victoria and Albert Museum, the British Museum, and the Yorke Collection of the British National Trust.

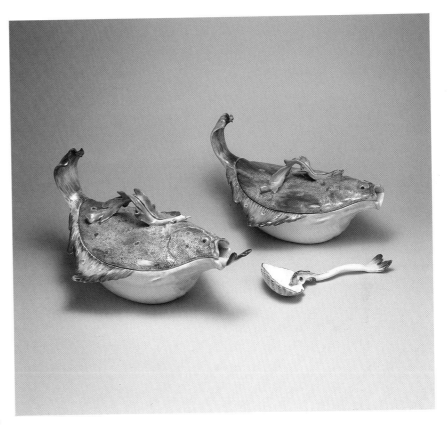

Tureen and Stand, ca. 1760
Porcelain
Tureen: 14 x 17½ x 15⅜ inches
(35.6 x 44.5 x 39.1 cm)
China, for the European market
Purchase with funds from the
Decorative Arts Acquisition Trust,
1984.78

This tureen is an instance, common in the eighteenth and early nineteenth centuries, of Chinese efforts to compete with the developing European porcelain factories by duplicating popular Western forms. This bold rococo shape probably appeared first in continental silver at about mid-century, inspiring French and German pottery and porcelain factories to adapt the form. One of these European ceramic adaptations was undoubtedly the model for this Chinese version.

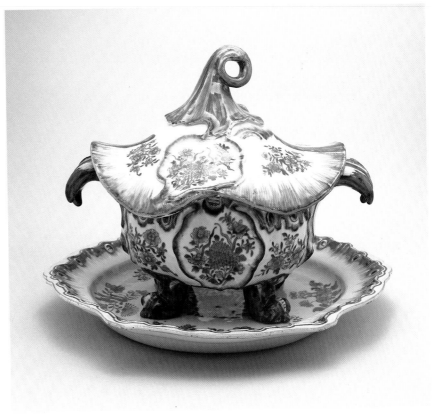

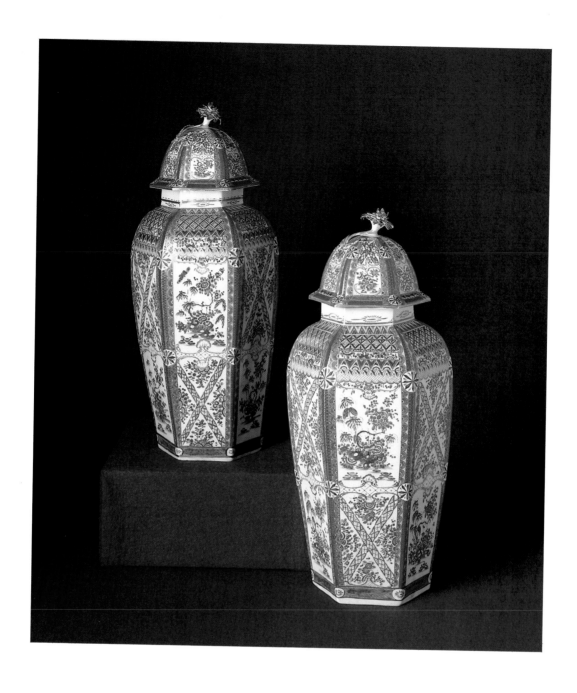

Pair of Vases, ca. 1765
Porcelain
16¼ x 6½ x 6½ inches
(41.3 x 16.5 x 16.5 cm)
Worcester Porcelain Factory
(1751-1792), Worcester, England
Emory and Frances Cocke
Collection, 1984.77.1 and 1984.77.2

The form and complex decoration
of these Worcester vases are
derived from Japanese models. As
is characteristic of Worcester por-
celains from the 1760s, the shape

and ornamentation complement
one another. Not intended for use,
the pair of vases may have orig-
inally been incorporated in an
architectural decorative scheme.
The orange, blue, and green
("shagreen" was especially popu-
lar) decoration is reminiscent of
eighteenth-century Japanese
Imari wares.

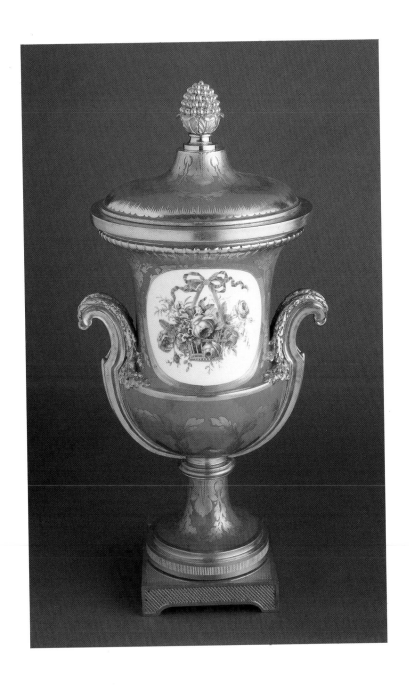

Covered Vase, ca. 1770
Porcelain and gilt bronze
18½ x 18¾ inches (47 x 47.7 cm)
Manufacture Royale de Porcelaine
de France (1756-1780), Sèvres,
France
Gift of Mrs. James B. Riley in
memory of her husband, James B.
Riley, 1977.1000.20

Early French porcelains followed
Meissen and Chinese prototypes in
form and decoration. In the last
half of the eighteenth century,

however, a distinctive French
taste – at first Rococo and later
Classical – emerged. Vibrant color
grounds, usually blue or green,
characterize the output of the
Sèvres factory. Following general
continental custom, the French fac-
tory received royal patronage, but
experienced chronic financial diffi-
culties. In addition to providing for
French royalty, Sèvres produced
wares for George III of England
and Empress Catherine of Russia.

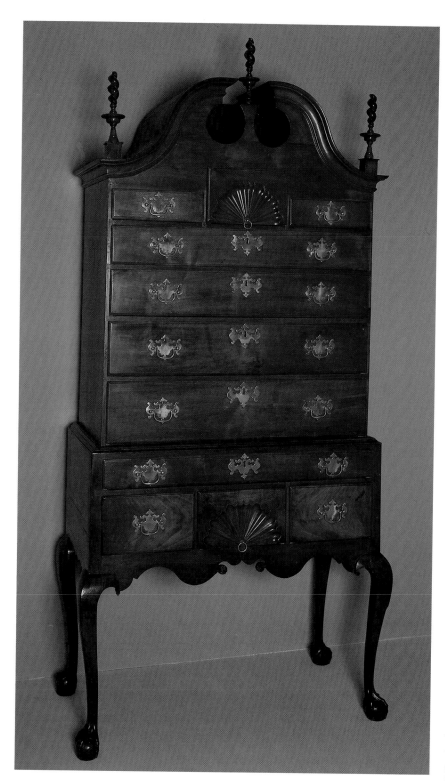

High Chest, ca. 1760-1780
Walnut and white pine
88 x 42¼ x 22¼ inches
(223.5 x 108 x 56.5 cm)
Salem, Massachusetts
Purchase with funds from a
Supporter of the Museum,
1976.1000.6

Salem was an important port in
the eighteenth and early nine-
teenth centuries. A distinctive
school of cabinetmaking developed
in the area, characterized by such
details as the curving skirt with
carved pinwheels and the ogee-
bordered carved shells on this high
chest, a furniture form derived
from the seventeenth-century
chest-on-stand. Original finials and
brasses distinguish this piece,
which descended in the Stephenson
and Storer families of Lowell,
Massachusetts.

Windsor Armchair,
ca. 1765-1790
Various woods, brown paint over
original black
42 x 24¼ x 15½ inches
(106.7 x 61.6 x 39.4 cm)
Philadelphia, Pennsylvania
Purchase with funds from the
Decorative Arts Endowment in
honor of Mrs. Harold Barrett,
President (1984-85) of the Members
Guild, 1985.16

Windsors were the common chairs
of eighteenth-century America.
George Washington ordered
twenty-seven for the portico of
Mount Vernon. They were used in
public buildings and homes,
indoors and out, in city and coun-
try. Generally made of various
woods (as best suited for seats,
spindles, legs, and crests), the
chairs were painted for a uniform
appearance. They were inexpen-
sive and were used everywhere;
their very commonness at the time
of manufacture makes great sur-
viving Windsors rare. The bold
turnings of the legs, the shield-
shaped seat, the knuckle-carved
arms, and the rakish angle relate
this chair to a group known to
have been made in Philadelphia, a
Windsor-chair-making center at
the time of the Revolution.

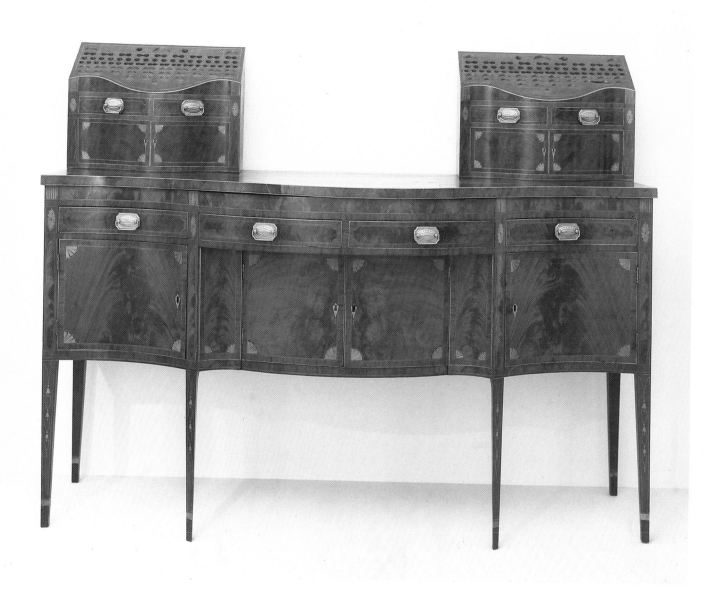

Sideboard with Matching Flatware Boxes, ca. 1794-1799
Mahogany with lighter veneers over poplar
40⅜ x 72 inches (100.6 x 180 cm)
Made by William Whitehead (working 1794-1799), New York City
Purchase with funds from a Supporter of the Museum, 1976.1000.5

In the early years of the Republic, domestic room usage became more specific, and areas set aside for dining and entertaining were common in affluent American households. The sideboard, a new furniture form made specifically for serving and storing utensils, was introduced at this time. The Museum's sideboard, with highly figured veneers, delicate attenuating legs, and tight composition of straight and curved surfaces, is typical of the finest American furniture of the Federal period. The original flatware boxes echo the form and decoration of the sideboard. The board retains fragments of the printed paper label of New York cabinetmaker William Whitehead, and descended in the family of John Fulton (1739-1842) of Red Hook, New York.

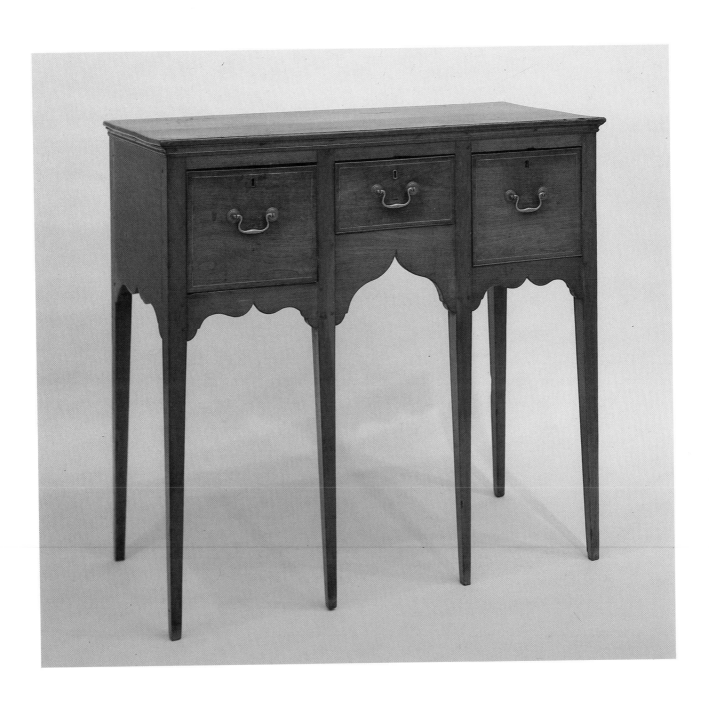

Sideboard, ca. 1800-1825
Walnut and yellow pine
46 x 49½ x 22½ inches
(116.9 x 125.8 x 57.2 cm)
Athens area, Georgia
Gift of Virginia Campbell Courts,
1977.1000.5

The tall and narrow proportions of this sideboard link it with other known examples of furniture and architecture from the Piedmont section of Georgia. Used for serving, the sideboard was also a secure storage for valuables, liquors, and foodstuffs. In the 1920s, collectors often referred to this distinctive southern form as a "hunt board." The term, however, does not appear in early nineteenth century Georgia inventories, advertisements, or other documents, and this piece was probably called either a sideboard or a slab. The square, tapering legs are in the up-to-date Neo-Classical or Federal style of the early nineteenth century, but the ogee-shaped skirt is a hold-over from the vocabulary of eighteenth-century American furniture design.

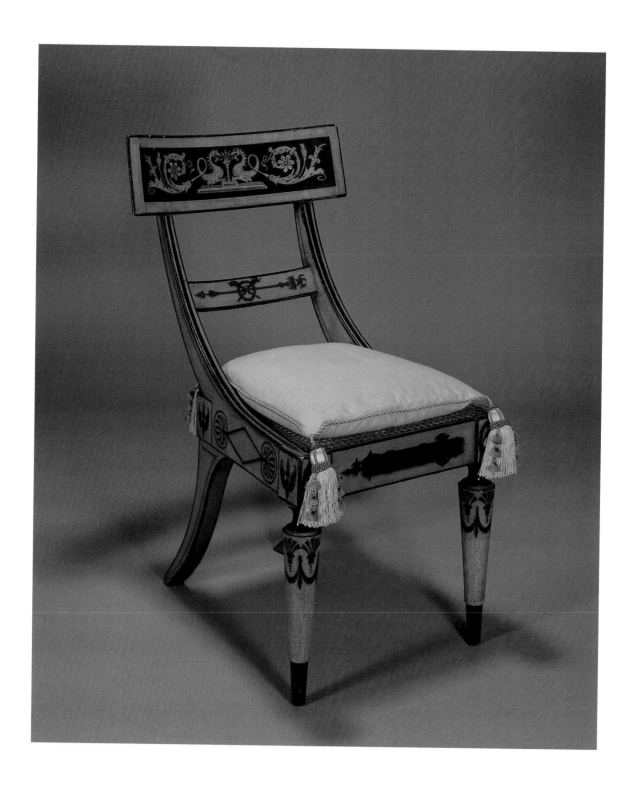

Side Chair, ca. 1815-1825
Painted maple with caned seat
34½ x 23 x 17¾ inches
(87.7 x 58.5 x 45.1 cm)
Baltimore, Maryland
Purchase with funds from the
Decorative Arts Acquisition Trust
in honor of Kendall Zeliff,
1981.1000.11

After the American Revolution, Baltimore emerged as a major shipping, mercantile, and manufacturing port. In the early nineteenth century the city became a furniture-making center, known for delicate painted forms based on English Regency prototypes. This chair is part of a large set made for

newspaper executive Arunah S. Abell, founder of The Baltimore Sun. The chairs were used at his Baltimore estate, Woodbourne. Other chairs from the set are now owned by the Metropolitan Museum of Art, the Baltimore Museum of Art, and a descendant of Abell.

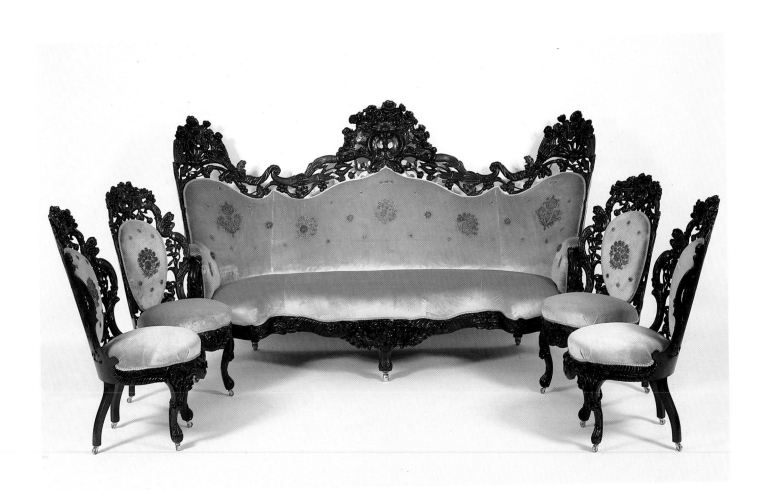

Sofa and Side Chairs, ca. 1855
Laminated and carved rosewood,
white pine, ash, gilt brass castors,
original applique medallions on silk
plush velvet
51½ x 91¾ x 38½ inches
(130.8 x 233.1 x 97.8 cm)
Attributed to John Henry Belter
(1804-1863), New York City
Virginia Carroll Crawford
Collection, 1981.1000.61-1981.1000.65

German emigrant John Henry
Belter patented the process of lam-
inating wood sheets to create the
curved backs on the carved
furniture made in his New York
factory in the 1850s. Although the
technique was imitated and
adapted by many manufacturers at
the time, Belter's name survives as
a kind of generic term for furniture
in this elaborate and convoluted
Rococo Revival style. The silk
velvet upholstery covering is an
identical modern replacement of
the original. The original medal-
lions, embroidered in silvered
threads, have been re-applied in
their original configuration. Fol-
lowing mid-nineteenth-century
custom, the sofa and chairs were
part of an extensive parlor set
which might have included other
sofas and settees, chairs, tables,
étagères, and cabinets.

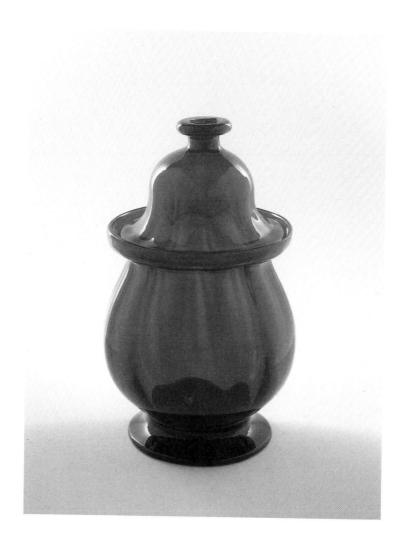

Sugar Bowl, ca. 1815-1840
Glass
6¾ x 4 inches (17.2 x 10.2 cm)
Pittsburgh, Pennsylvania
Purchase with funds from the
Decorative Arts Acquisition Trust,
1981.1000.9

Free-blown and patterned in a
twelve-rib mold, this sugar bowl is
of a type often associated by early
collectors with a group known as
"Bakewell bowls." Though no docu-
mentary evidence links this bowl
with the well-known Pittsburgh
company, the form and distinctive
blue-purple color are typical of the
wares produced there in the early
nineteenth century. The bowl was
included in a landmark Girl Scout
exhibition of American furniture
and glass in New York in 1929,
when it was part of the collection of
the pioneer American glass dealer
and scholar George S. McKearin.

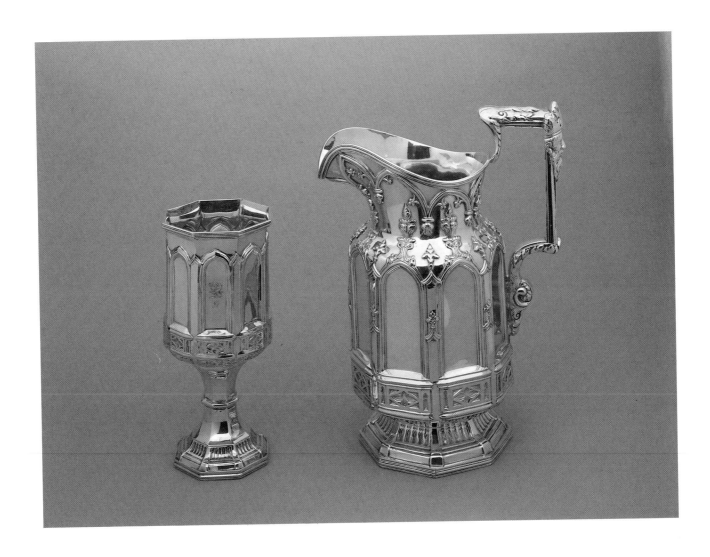

Pitcher and Goblet, ca. 1845
Silver
Pitcher: 11 x 8½ x 5½ inches
(28 x 21.6 x 14 cm)
Goblet: 8 x 3⅞ x 3⅝ inches
(20 x 7.8 x 8.6 cm)
Zalmon Bostwick (working
1845-1852), New York City
Virginia Carroll Crawford
Collection, 1984.142.1 and 1984.142.2

Throughout the nineteenth cen-
tury, the Gothic was a recurring
popular revival style. The earliest
American expressions date from
the 1840s, when Andrew Jackson
Downing and architect Alexander
Jackson Davis promoted the style.
Gothic motifs were most fre-
quently adapted for religious and
domestic architecture and furni-
ture. Only rarely were they used in
ceramic, glass, and silver wares.
This is one of two drinking sets,
unusually rich in detail, ordered by
wealthy New Yorker John
Livingston for his son-in-law
Joseph Sampson. The matching
pitcher and goblet are in The
Brooklyn Museum. Contemporary
ceramic pitchers in the same form
survive from both English and
American potteries.

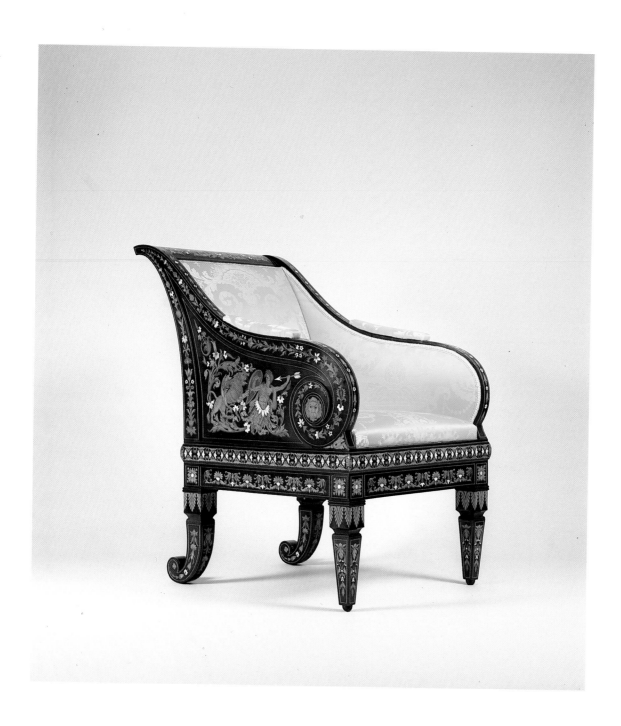

Armchair, ca. 1875
Ebony with marquetry of ivory,
mother-of-pearl, red pine and
lighter woods
38¾ x 26¾ x 35 inches
(98.5 x 68 x 88.9 cm)
Probably New York City
Virginia Carroll Crawford
Collection, 1983.196

The Neo-Grec or "modern classical" style was embraced by American furniture-makers and designers during the 1870s. The monumental scale, sabre front legs, scrolled arms, and volute-terminated rear legs, together with the classical motifs of the marquetry, associate this armchair with the popular post-Civil War revival style. The chair is one of a pair (the mate is in the Metropolitan Museum of Art),

and similar chairs with different coats of arms are in the Museum of the City of New York, The Brooklyn Museum, and the Museum of Applied Arts and Sciences in Sydney, Australia. The High Museum's chair bears the arms of the Kennedy family and was probably made for Robert Lenox Kennedy, a noted bibliophile whose collection is now in the New York Public Library.

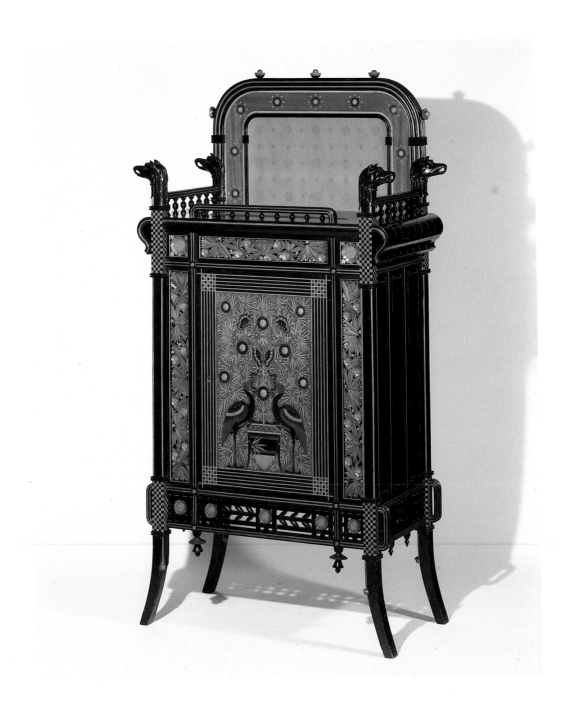

Cabinet, ca. 1880
Ebonized cherry, marquetry of
lighter woods, gilt decoration
60 x 33 x 16¼ inches
(152.4 x 83.9 x 41.3 cm)
Herter Brothers (working
1865-1908), New York City
Virginia Carroll Crawford
Collection, 1981.1000.51

Herter Brothers was the leader
among many interior decorating
firms flourishing in New York City
during the late nineteenth century.
Wealthy and worldly patrons com-
missioned singular examples of
"Art Furniture," a Herter spe-
cialty. The integration of pattern
with form and the distinctive
marquetry door in the refined Jap-
anese mode illustrate the firm's
introduction of sophisticated
English "Aesthetic Movement"
visions into American taste during
the 1880s. A similar cabinet,
executed in lighter woods and also
stamped "HERTER BRO'S," is at
Sagamore Hill, the Long Island
residence of Theodore Roosevelt.

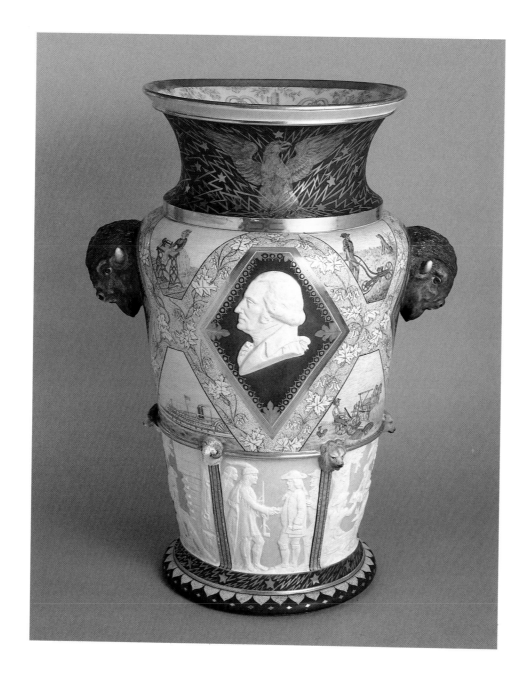

Vase, 1876
Porcelain, glazed and bisque with
gilt decoration
22½ x 12 x 12 inches
(57.2 x 30.5 x 30.5 cm)
Designed by Karl Müller, Union
Porcelain Works (1862-1912), Green
Point, Long Island, New York
Virginia Carroll Crawford
Collection, 1986.163

A pair of robust monumental vases
were made by the Union Porcelain
Works to celebrate the first cen-
tury of American independence. In
the summer of 1876, the vases were
shown at the Great Centennial
Exhibition in Philadelphia's Fair-
mont Park. Like the international
fair itself, the vases not only com-
memorated the founding of the
nation, but celebrated the phe-
nomenal technological progress of
its first century, suggesting that
historical events like the Boston
Tea Party and William Penn's
Treaty with the Indians (here
depicted in biscuit) made possible
such innovations as Fulton's steam-
boat and the telegraph (shown in
polychrome). The American eagle,
George Washington, and heads of
native American animals carry out
the elaborate American themes.
The mate to this vase is in The
Brooklyn Museum.

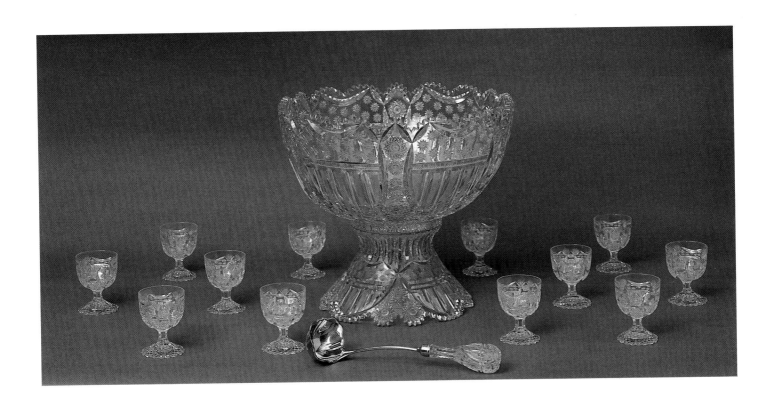

Punch Set, 1898
Cut glass and silver
Bowl: 17 x 18 inches (43.2 x 45.7 cm)
Cups: 4⅛ x 3⅛ inches (10.5 x 8 cm)
Ladle: 13 inches (33 cm)
Libbey Glass Company (1888-1936),
Toledo, Ohio
Purchase with funds from the
Decorative Arts Endowment,
1985.51.1-1985.51.15

In order to ensure delivery of an
undamaged punch set to the White
House for Christmas 1898, during
the presidency of Ohioan William
B. McKinley, Libbey craftsmen
executed two sets. The original
shipment arrived safely, but was
later lost. The company retained
this twin set for several years,
exhibiting it at the Louisiana Pur-
chase Exposition in St. Louis in
1904. According to contemporary
accounts, the Presidential Punch
Bowl took Libbey cutters four
weeks to execute and was the
largest piece of cut glass made up
to that time.

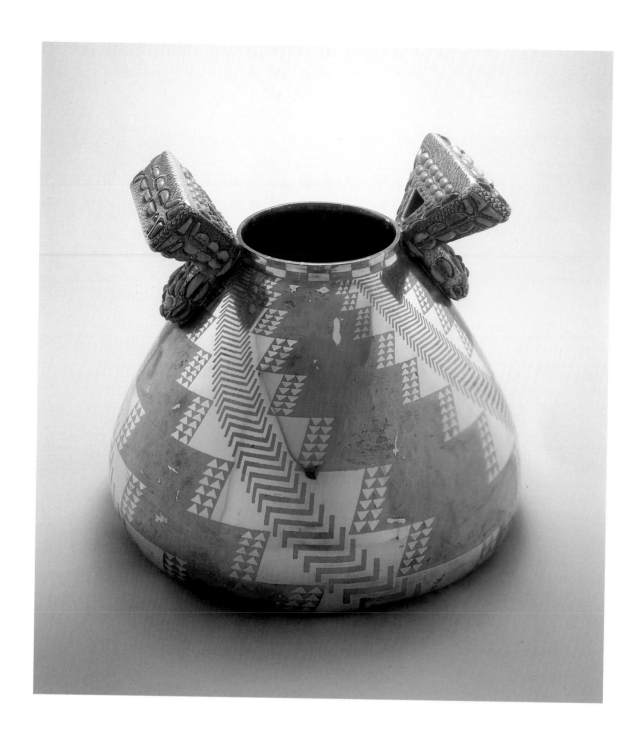

Vase, ca. 1900
Silver, copper, and turquoise
7½ x 8¾ x 9 inches
(19.1 x 22.3 x 22.9 cm)
Tiffany and Company (established
1837), New York City
Virginia Carroll Crawford
Collection, 1984.170

The sources of eclectic American
taste in the early twentieth
century were many and varied.

American native Indian design
inspired several works executed by
Tiffany and Company at the time.
The geometric pattern in copper
and silver is reminiscent of South-
western Indian basket design. The
handles, in the form of snake
heads, recall American Indian
jewelry traditions. The simple
angular patterns of Indian inspira-
tion fit with the tenets of the Arts
and Crafts Movement in America

and were a precursor of American
Art Deco of the 1920s. The vase
was made for exhibition at the 1900
Paris Exposition Universelle and
was again exhibited by the firm at
the 1901 Pan-American Exposition
in Buffalo, New York, but the style
had little international impact.

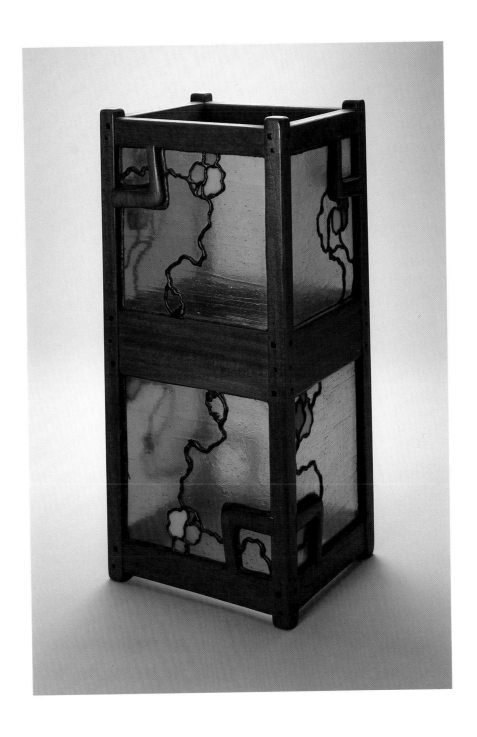

Wall Lantern, ca. 1906
Mahogany and ebony, leaded glass
17³/₄ x 8 x 7½ inches
(45.1 x 20.3 x 19.1 cm)
Designed by Greene and Greene
(working 1893-1920)
Woodwork by Peter Hall, glass-
work by Emile Lange
Pasadena, California
Virginia Carroll Crawford
Collection, 1985.320

Like Frank Lloyd Wright, their
midwestern contemporary, the
Greene brothers developed a read-
ily identifiable regional style at the
beginning of the twentieth cen-
tury. Their innovations, combined
with eclectic mixtures of elements
from Arts and Crafts, Japanese,
American Indian, and Tudor
Revival design, characterize their
work. Also like Wright, Greene
and Greene designed or selected

the furnishings for their commis-
sions. The results were buildings
remarkable for their unity of
design and excellence of craftsman-
ship. The Museum's lamp was part
of the furnishings of the James
Culbertson house in Pasadena, a
1904 Greene and Greene commis-
sion. In 1906, the house was
remodelled by the firm, and the
lantern dates from that renovation.

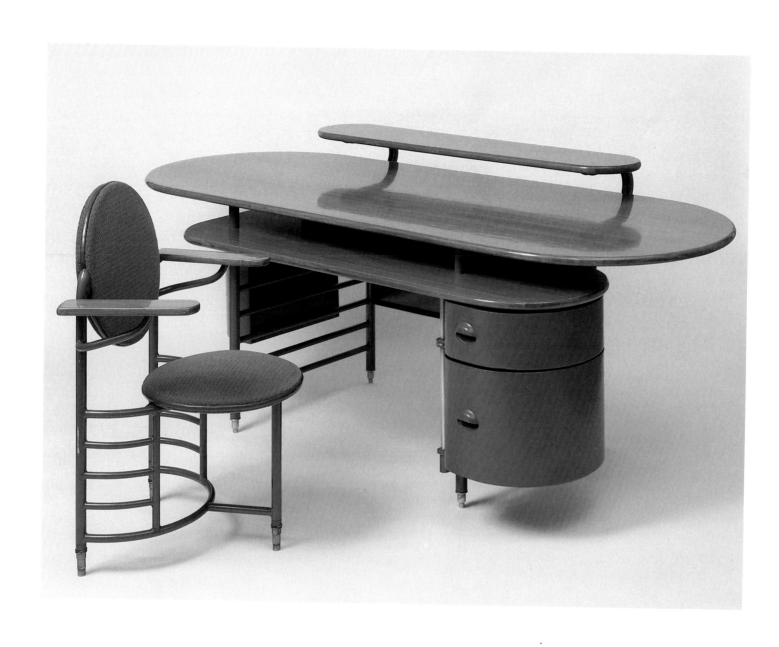

Desk and Chair, ca. 1936-39
"Cherokee" red enamelled steel
and walnut
Desk: 33½ x 35 x 84 inches
(85.1 x 88.9 x 213.4 cm)
Chair: 34½ x 23½ x 19 inches
(87.6 x 59.7 x 48.3 cm)
Designed by Frank Lloyd Wright
(1867-1959)
Manufactured by Steelcase, Inc.,
Grand Rapids, Michigan
Purchase with funds from the
Decorative Arts Endowment,
1984.371.1 and 1984.371.2

Frank Lloyd Wright first achieved
fame as the foremost American
architect of the twentieth century
with his designs for "Prairie
School" houses at the turn of the
century. In the 1930s, with his
career in the doldrums, Wright
was commissioned to design the
S.C. Johnson Administration
Building in Racine, Wisconsin. The
metal office furniture he created
for the great workroom in the
Administration Building reflected
the overall form of the structure.
The international acclaim which
the Administration Building and
its furnishings received re-estab-
lished Wright's prominence and led
to a third phase in his career, which
culminated in the Simon R.
Guggenheim Museum building in
New York City.